HAUNTED
PANAMA CITY

HAUNTED
PANAMA CITY

BEVERLY NIELD

Published by Haunted America

A Division of The History Press

Charleston, SC

www.historypress.com

Back cover image courtesy of the Bay County Library.
All images are from the author's collection unless otherwise noted.

First published 2018

Manufactured in the United States

ISBN 9781467137362

Library of Congress Control Number: 2018942434

Dedicated to my cousin Karen Murphy, with whom I share a love of all things strange and mysterious. This fascination was passed down to us by our much-loved grandmother, Jesse Irwin. Also to my mother, Jillian Carrick, who encouraged me to love books and read widely.

CONTENTS

ACKNOWLEDGEMENTS

I wish to thank the staff at Bay County Library for being so helpful and knowledgeable.

Thanks to Tony Simmons, editor of the *News Herald*, for his advice and newspaper articles. I am also indebted to previous works by Marlene Womack and Dale Cox that have been written about local hauntings.

I wish to thank all the people who have helped by telling me their stories. Also, thank you to Paul Bonnette for his help with the haunted tour.

Last but not least, I wish to thank my family, both immediate and extended, for the times they have helped me with technical issues, photographs and visits to graveyards, sometimes in pouring rain or fighting through stinging nettles, to find an ancestor or follow a line of inquiry.

INTRODUCTION

L ocated in Bay County on the emerald shores of the Gulf of Mexico, between Tallahassee to the east and Pensacola to the west, is the town of Panama City. The miles of white sandy beaches in the area known as the Florida Panhandle make for a much sought-after holiday destination. Although tourism is a major industry nowadays, timber, turpentine, shipbuilding and fishing were the region's main industries in the past, and their remnants are still in evidence in the Panhandle today.

At the heart of downtown Panama City is the Robert Lee McKenzie House. This historic building with its clapboard frame in Dutch Colonial style was built in 1909 by Belle Booth, the local postmistress, who later married McKenzie in 1912. McKenzie was the first mayor of Panama City, and between 1902 and 1956, he was extremely influential in developing the town. McKenzie bought waterfront property in the area, as he saw the potential for a trade route via rail between Atlanta and the Gulf shore and from the port over the sea to the Caribbean entrance to the Panama Canal.

In the 1880s, Panama City was composed of three 640-acre homesteads. Later in the decade, developers Clark B. Slade, C.J. Demorest and G.W. Jenks encouraged growth in the area and used the names Floriopolis and Park Resort. In 1889, the first post office was built, and the name was changed to Harrison. Downtown, Main Street still bears the name Harrison Avenue and, according to local paranormal investigators, has a high level of paranormal activity.

The town was granted a charter on February 23, 1909. Panama City was renamed at this time. George Mortimer West, a leading businessman and instigator of the local newspaper, the *Panama City Pilot*, began a publishing company here in 1906. The historic building in St. Andrews that housed this operation is now a museum. West, known fondly as the "father of Panama City," was instrumental in the growth of the railroad. The Atlanta and St. Andrew Bay Railway Company came to the town, and the city began to grow. A.B. Steele suggested the name Panama City, as he thought the interest in the Panama Canal would encourage real estate investment in the area.

Later in the twentieth century, Panama City was an infamous destination for spring break until drinking on the beaches was banned for the month of March. It is home to Tyndall Air Force Base and the Naval Support Activity Panama City and is also the site of the well-known Supreme Court case *Gideon v. Wainwright* in 1963, which confirmed a defendant's right to legal counsel, even if he could not afford to hire his own attorney.

Yet despite its sunny shores, emerald waters and raucous crowds of spring breakers, ghostly forces have been rumored to lurk in Panama City's shadows.

PART I

PANAMA CITY

THE MARTIN HOUSE

The most notorious haunted story in Bay County is that of the Martin House, built in 1910. It is located in Millville on the outskirts of Panama City across the road from the pulp mill. Economically valuable to the area, this mill was built in 1930 by the International Paper Company. Since that time, it has had various owners, the most recent being RockTenn Co., which took ownership in 2011. The mill has been in existence for eighty-five years and is still going strong and billowing out smoke today.

The Martin House sits empty and alone on a hillside overlooking the mill, surrounded by a high barbed-wire fence with many NO TRESPASSING signs attached to the mesh. Low-hanging Spanish moss on the live oaks coupled with the mists from the nearby Martin Lake lend the house and grounds an eerie, desolate air.

Local legend states that patriarch John Martin, in a moment of madness, murdered his wife and three children before turning the gun on himself. The shed where the alleged suicide took place still exists. To this day, rumors fly about satanic rituals nearby, possibly on the second floor of the house, and ghostly footsteps haunt house guests.

But truth and rumor do not always align, and records show that the Martin family massacre never occurred. However, Martin and his family were reportedly victims of supernatural happenings themselves.

According to my research, John D. Martin and his family moved to Millville from his plantation in Holly Springs, Mississippi, in 1885. He purchased some land where he lived with his wife and three children. His mother, Sarah Dickens Martin, bought land adjacent to her son. On her

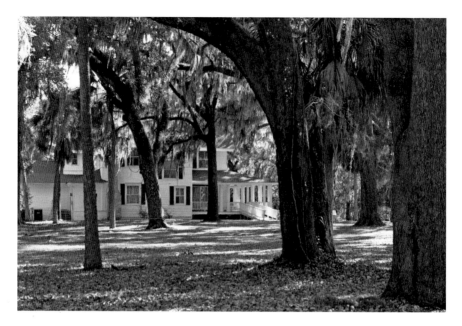

The Martin House.

property was an old house where a killing was said to have taken place. Locals claimed the house was haunted. Rumors whispered of a pool of blood that never dried and could not be scrubbed away. A window would break and magically repair itself over and over. Apparently, the Martin family "endured strange occurrences over the years," according to an undated article in the *Gulls' Cry* by Nancy Schwartz. These happenings took the form of strange and unexplained lights. Sarah was in the habit of leaving her large two-story house in the evening to walk up the hill to join her family. During one of these visits, as the family gathered on the veranda, they noticed a light blinking in Sarah's house. The menfolk set off down the slope to see who the visitor was. Upon their arrival, the light mysteriously extinguished. They searched the house but found no evidence that anyone was, or had been, there. This phenomenon began to occur with increasing frequency. Every time the family arrived, sometimes carrying guns for protection, they would get to the house only to have the light disappear as soon as they reached the doorstep. Sarah's house was eventually demolished by the paper mill and turned into a parking lot.

The Martin House was bought by the paper mill and rented out for private parties in the 1970s. It is not open to the public and, in spite of renovations in the 1980s, does not appear to be in use.

According to available records, it was not the ghostly happenings that drove the Martin family away from the house but the death of a dolphin. They used to watch a particular dolphin in the bayou; they considered him a friend, as he would lift his head out of the water regularly as if to say hello to them. One day, they discovered his body washed up on the shore, poisoned by the polluted water. The Martins decided it was time to move.

John D. Martin's daughters lived to a ripe old age not too far away and died of natural causes. Ruth taught at Holy Nativity School, and Catherine was a postmistress in Southport. They are buried in Parker Cemetery along with other family members.

The son, Andrew Lee Martin, was a captain at age twenty-six when he set off from Port St. Joe in a two-masted schooner named *Cleopatra* with mate Bragg Butler on a trip to Pensacola to deliver 110 barrels of resin. They had not gone far when a severe storm, Hurricane Irma, hit. The ship overturned, and the two men almost made it to shore in a dinghy but capsized and drowned within sight of land at Bell Shoals. Bragg's body was found on January 31, 1909, on the beach. Andrew's body was found nearby a few weeks later, partly covered with sand.

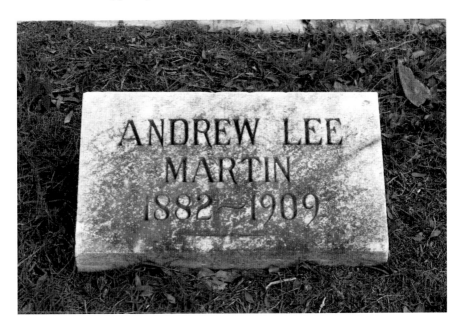

Andrew Lee Martin gravestone.

So how did rumors of murder start? Maybe the old stories of strange occurrences at Sarah's house transferred in popular imagination to the still-standing Martin House. Perhaps stories began and grew over the years, as the location has been the site of numerous strange and unpleasant happenings. There are rumors of satanic rituals and the hanging of a supposed witch in the area in the early 1800s. There are also tales of suicides, murders, wagons falling off the bridge into the water and swimmers chancing upon bodies in the bayou that are not to be found when searched for later.

I had my own personal spooky occurrence while researching the legends for this chapter. While poring over the Martin/Davidson family tree, I stumbled across the name Irwin. This is a family name for me too—a common Irish name, as is Davidson. But a close search revealed that both families, John Davidson Martin's and mine, came from the same small parish in County Armagh, Northern Ireland. How curious is that?

Maybe John Martin wants his distant relative to clear his name of the family-murdering rumors once and for all.

THE RITZ

Looking across Harrison Avenue to the Art Deco façade of the Martin Theatre puts bystanders in mind of times gone by—a life before television, when people had to go out for entertainment and a new movie coming to town would be awaited with growing anticipation and excitement.

This site, 409 Harrison Avenue, has a long and varied history. Earliest recollections have it as a morgue and crematorium before the present-day building was erected. Originally called the Ritz and owned by Mr. Martin and Mr. Davis, this cinema saw over five thousand people walk through the doors on opening night, November 24, 1937. Many declared it to be "the most beautiful of any theater in the state." The *Bay Bizz* magazine in 1990 reminds us of the leather seats, ample stage, dressing rooms with showers and climate control, along with a silk curtain with rainbow motif.

This theater was used for pageants, talent shows, concerts and such movies as *This Is the Army*, starring Ronald Reagan, in 1943; proceeds were kindly donated to Army Emergency Relief. The theater also boasts Clark Gable as one of its visitors, as he appeared at a patriotic event during his stay at nearby Tyndall Air Force Base.

The theater closed in 1978. Drive-ins and television in nearly every home had led to its decline. Sadly, the building was left to deteriorate until 1985, when it opened as Dead Eye Jack's, a shooting range. Expected clients were hunters and law enforcement officers who could practice shooting at the twenty-one human-shaped targets. This lasted a year before it was left empty yet again.

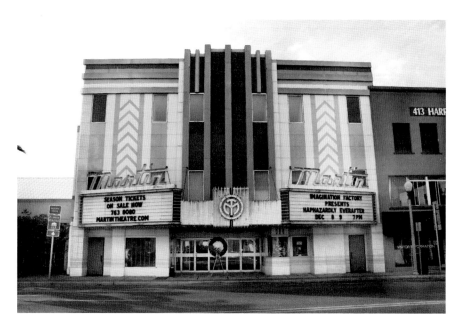

The Martin Theatre.

On Monday, November 19, 1990, fifty-four years after it was originally built, the theater reopened as a 469-seat multipurpose arts facility. The inside boasted a deep pile carpet in shades of green, gold and red. Images of classic cartoon figures like Betty Boop, Popeye and Minnie Mouse graced the walls.

With such a busy history, it is hardly surprising that this has been the site of ghostly activity. Barbara McGinnis, an employee who has been involved with the theater since the 1990s restoration, related tales of staff hearing footsteps at night in the offices upstairs when the place was supposedly empty. Sometimes tables and chairs would be rearranged after having been set up for a special event the day before. Shadowy figures have been glimpsed walking up and down the spiral staircase on stage left. Spookier still, on one occasion, all the curtains were lifted before locking up for the night, only to be found dropped down early the next day. One time, a picture was taken in the dressing room mirror. The image revealed another form standing behind the photographer, looking over her shoulder.

A young male apprentice was seriously frightened one day when he went downstairs to a restroom. He turned white as a sheet and would not go back downstairs on his own again. He described what he had seen as a glowing light but with an unearthly quality.

A young female actress would regularly lose one or both shoes, only to find them later in another dressing room. Parts of costumes might be spirited elsewhere too. The so-called ghost light glows perhaps for the spirits of actors who have departed the stage or, more usefully, is left on so the backstage crew members don't stumble in the dark. It has a habit of turning itself off, thereby annoying the production crew. This ghost has an impish nature.

Investigations by a local paranormal group have discovered various activity, according to Tony Simmons in the *News Herald* of Sunday, June 12, 2011: "A woman reported hearing her name called when no one was around. One man heard a dog running in a downstairs hallway and another reported seeing a 'black mass' moving up a catwalk." Other people claim to have heard a dog growling. Apparently, it is quite large and has been seen running in an aisle before disappearing.

A paranormal group identified at least six spirits, including a prostitute and a theater manager who committed suicide. Little wonder many members of the staff, including some who are skeptics, are not keen to be alone in the theater at night.

Theaters are no strangers to ghosts. Kaleidoscope Theatre in Panama City has a spirit that likes to smoke cherry-flavored tobacco. Club members looking up one night after rehearsing saw someone moving in the tech box. On investigation, no one was there, but a distinct aroma of cherry pipe tobacco was present.

THE OLD COUNTY JAIL

At 19 East Fourth Street, with its ornate doorway facing the street, is the original entrance to what used to be city hall, a police station, a fire station and a jail. Designed by architect E.D. Fitchner and built in 1925 by J.R. Asbell at a cost of $35,000, city hall was decorated in Spanish Revival style with areas of Art Deco, Neoclassical, Gothic and Baroque features. The stucco has many pieces of multicolored glass and is rumored to be the only one of its kind still standing in Florida. The Panama City Center for the Arts now occupies the location.

According to Marlene Womack in an essay titled "Heart of the City":

> *The architect chose classical decorative elements to enhance the public nature of the building. The double cornucopias over the archway symbolize abundance, productivity and wealth of the City. The miniature obelisks, which act as finials for the façade, come from the use of Egyptian obelisks in Rome to mark the way for pilgrims visiting important religious sites and as such became the symbol of important public buildings. The urn at the uppermost point of the building is a trophy symbol indicating victory.*

The beauty of the building belies the tragedies of its past. The jailhouse was the scene of the lynching of Miles Brown, who allegedly killed his former employer, Roy Van Kleek, businessman and owner of two local hardware stores. Although Brown was convicted, the jury asked for mercy in his sentencing. A mob of masked men bound and gagged the jailor at

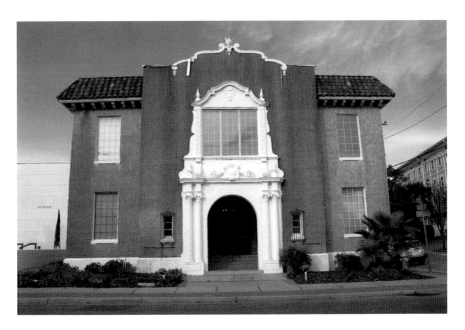

Panama City Center for the Arts.

about 3:00 a.m. on April 1, 1939. They took Brown outside and shot him. One of the mob members spoke, saying, "The law didn't do justice, but we will." His body was thrown along the side of the road, where it was found some three hours later. Rumor has it that his dead body was displayed for all to see in a storefront window on Harrison Avenue. The masked men were never identified.

Members of arts center staff have complained of hearing footsteps pacing back and forth in the area that used to be the prison cells. They have also experienced a feeling of being watched and hearing voices. I spent the night in this building with a paranormal group, and although I did not meet any ghostly figures, there was much activity on the sonar equipment, especially in the area of the cells. Perhaps the ghostly footsteps belong to Miles, haunting the scene of his last few days on earth.

Before the old county jail was built, prisoners might have been placed in a cage jail. There was little hope of escape, as the contact between jailer and prisoner was minimal. No cell doors needed to be opened, as food and water were passed through a small opening in the cage. I am not sure if the Panama City steel cage jail at the foot of Harrison Avenue—pictured in the Bay County Library collection with Charles E. Scott, second sheriff, guarding a prisoner in 1914—is quite as awful as the squirrel or rotary cage.

The most infamous of these can be seen in Pottawattamie, Iowa. The cage in this location was in use from 1885 to as late as 1969. As the cages were rotated by the turning of a crank until lining up with the small aperture for food, legs and arms might be severed or heads crushed. The system might jam, cutting prisoners off from food and water for some days. Evacuation in the case of a fire was all but impossible. What a cruel system and how amazingly late it was in use.

VIRGINIA

The cornerstone for the new Bay County Courthouse was laid on Tuesday, December 22, 1914. It was a beautiful day with clear blue skies, and spectators came from all over the county, as this was an exciting event for those days, with no television on which to watch the ceremony. A special train was scheduled from Lynn Haven so as many people as possible could witness the event.

The courthouse was needed to house offices, a courtroom and a jail. The crimes tried here were mostly cattle rustling. Other cases noted included horse stealing, breaking and entering and the theft of a steer.

In 1916, J.M. Sapp was the prosecuting attorney. I mention him as he lived at 224 East Third Street in a beautiful old house mentioned on the Downtown Historic Walking Tour. Sapp used scaffolding from the nearby courthouse to build this home. It was the first in the area to have two bathrooms with hot water and an elevator. The front porch was a popular meeting place for politicians, attorneys and others to discuss current events. It is one of four houses in Bay County to be included in the National Register of Historic Places. Despite its storied history, no tales of hauntings have come to light at this residence yet.

The courthouse, at 300 East Fourth Street, is one of five original courthouses still in use in the state of Florida. The architecture is Classical Revival. Although it was established in 1915, much had to be rebuilt after a fire that started in the jail in a pile of old mattresses at 4:00 p.m. on November 23, 1922. The fire was believed to be arson in an attempt to free

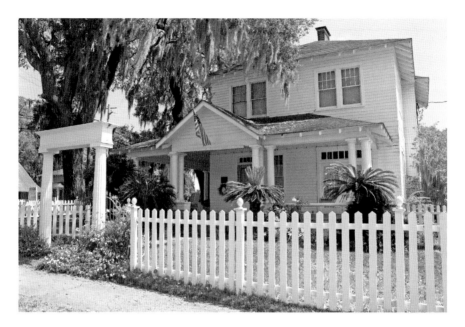

The Sapp House.

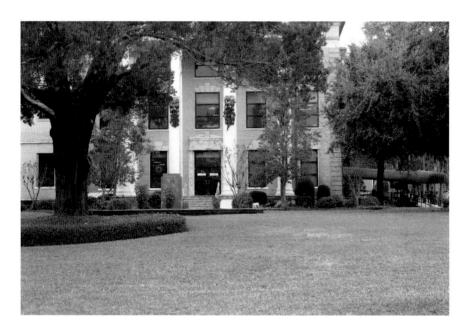

Bay County Courthouse.

some murderers. The criminals were secured elsewhere, so no one escaped. The sheriff tried to extinguish the fire with buckets of water but was beaten back by the smoke.

The great bronze bell survived the fire. It had pealed across the city in 1918 to let the roughly 2,500 people who lived in Panama City know peace had been declared in Europe as the Great War had ended at the eleventh hour of the eleventh day of the eleventh month. The bell can be found in a crate on Harmon Avenue.

The courthouse is best known for being the site of the historic case of *Gideon v. Wainwright* in 1961. The state and the nation established the public defender system as a result. Clarence Earl Gideon stood trial for burglary; a homeless drifter with a troubled childhood, he could not afford a lawyer but asked for one to represent him. The request was denied, as those charged with non-capital offenses had no constitutional right to free lawyers. Gideon had to represent himself. He had stolen beer and soda from a pool hall and allegedly taken fifty dollars from the juke box too. He was charged with breaking and entering and petty larceny and sentenced to five years in jail by Judge Robert McCrary Jr. While in prison, Gideon petitioned the United States Supreme Court to look into his case. In 1963, the ruling was made, enabling poor people charged with serious crimes to be given defense lawyers at public expense. Panama City attorney W. Fred Turner presided at the retrial and won acquittal for Gideon.

Rumor has it that the courthouse basement is haunted. Someone on the staff has even seen an apparition, as well as heard strange noises. The ghost is female and is referred to by staff as Virginia.

Another tale revolves around the elevators. Trying to get up and down has proved difficult for some attorneys, as the lift seems to have a mind of its own. The elevators travel farther down to lower floors than passengers had requested, sometimes even dropping to basements that do not have lift buttons, and then ascend to the attic before eventually and perhaps reluctantly arriving at the correct floor.

DOPPELGANGER

Doppelgangers, lookalikes or doubles of the living appear in legends and folklore throughout the world. Among the most well-known instances is the experience of Guy de Maupassant, a French novelist. Toward the end of his life, he saw his double walk into his room and sit down to read a book.

Another poet, John Donne, glanced up to see what he thought was his wife enter the room, holding a baby. But his wife was in another room giving birth to a stillborn child. How sad, but how intriguing. Could this have been an instance of bilocation, where someone is able to be in two places at once? Was this, in fact, astral projection, where the wife left her body temporarily and looked at the world from a different point from where her body was actually located?

Yet another writer—leading me to wonder if the extremely creative brain is more likely to experience this phenomenon—Percy Bysshe Shelley, saw himself standing on the shore, finger pointing to the Mediterranean Sea. Soon after this event, he died while sailing in these waters.

An example of this phenomenon occurred right here in Panama City. The paralegal at a local law firm heard strange noises. A hard worker, she often stays late at the office or enters the building on weekends. It was at these times when the building seemed deserted that she would hear footsteps in the hallway, as well as doors rattling, but no one was there. She has heard the back door open and shut and called out, thinking another member of staff had come into the office, but no one was there.

Two previous paralegals heard these noises too, but one witnessed something even more bizarre: she saw her boss and owner of the law firm in the building when he was proven to be elsewhere. These experiences have intrigued the staff at this establishment, and they are wondering if this is evidence of a doppelganger.

Doppelganger is a German word meaning "double goer" or "double walker." It refers to a lookalike for another person or a "dead ringer," we might say. Some people claim that we all have a shadow self somewhere. Others say that to see a person's double is a premonition of death or disaster.

There are numerous other stories of this kind. Queen Elizabeth I saw an image of herself dead in bed and died shortly afterward. No wonder people consider doppelganger sightings to be ominous portents. I am glad to report that in this case, the local attorney and paralegal who spotted his doppelganger are alive and well some years after the first vision took place.

As far as is known, there were no untoward occurrences in this building that might have caused it to be haunted. Built in the 1930s, it was once a restaurant and the original site of Angelo's Steak Pit, which is now found on Front Beach Road in Panama City Beach. On the outside of the building, an old pizza oven can be seen in the wall from its years as a restaurant.

The attorney's office where the doppelganger has been sighted.

When the building was remodeled as law offices, menus were found lodged behind the walls. In the 1960s and '70s, it was a lamp and light store. Later, it became a cobbler's shop called Howard's Shoe Repair. Repairs, however, were not made to the house, and the roof began to leak. It remained vacant for a few years.

When Hurricane Opal blew through Panama City in 1995, the building's roof ended up in the Baptist church parking lot across the street, and for a while, the building was in a state of disrepair.

Across the road from the law office is a sad building with blocked-in windows. Once called the Marie Hotel, it was a popular place for people to stay, built in the 1930s by A.R. Rogers on the corner of Fifth Street and Grace Avenue. It closed in 1985 and has been vacant since. A homeless person is said to have died in a fire on the premises. More deaths would have occurred at the other end of East Fifth Street as Panama City's Adams Hospital was erected there in 1924.

In conclusion, there is nothing that really explains why three different sets of employees spanning eight years have, unbeknown to one another at the time, experienced a sense that someone is in the building but no one has been there, except for, on occasion, the doppelganger.

HOTEL MARIE

Empty for over twenty years, the Hotel Marie sits forlornly at 490 Harrison Avenue, its gloomy blacked-out windows overlooking downtown Panama City. At one time, it was the go-to place downtown for tourists, traveling businessmen and locals who would visit for an eighty-nine-cent lunch composed of meat and two vegetables followed by dessert and tea, according to a 1958 issue of the *Panama City Pilot*.

The block was bought by Alson R. Rogers in 1939, at which time there were a few houses and a store at this location. Having been in the area since 1930, when he came as a concrete foundation contractor for the paper mill, Rogers saw the potential to develop this land.

In February 1939, he opened a hotel, named after his blond-haired, blue-eyed teenage daughter, Marie. It was a two-story building with a garage for fifty cars. There were thirty-six rooms with private bathrooms and telephones, and the hotel also included air conditioning, an unusual but much-appreciated enticement.

In 1940, a third floor was added so the busy hotel could accommodate seventy-two rooms. The building also housed a bank, barbershop, jewelry store, beauty salon and men's clothing store during its time as a hotel. In 1958, Rogers sold the hotel to A.M. Williams and son, who, in turn, sold it to Mr. Hildreth in 1964. Hildreth leased it to Bill Peeke. Peeke refurnished the hotel with rattan furniture and boasted of the fine furnishings, "The windows had velvet draperies and white tie back curtains. We had a nice brown carpet on the floor."

Hotel Marie.

By 1975, the number of people visiting downtown had dwindled so much that Peeke closed the hotel and the restaurant. The city continues to debate whether to raze it, turn it into affordable housing or return it to its former glory as a hotel.

At 1:00 a.m. on the morning of June 28, 1973, a murder took place in the lobby of Hotel Marie. Johnnie Creech, a middle-aged bellhop and night desk clerk, was shot in cold blood by a white male of approximately thirty years of age. A witness described him as being of medium build and small in stature, being only five feet, five inches in height. The killer walked into the foyer, spoke to Creech, left, went to his yellow-and-white pickup truck parked outside, returned to the lobby holding a shotgun and shot Creech. He then threw the gun on the floor, told the witness to call the police, walked out and drove off. The perpetrator of the crime was never found. The motive is unclear, but rumors of a connection to prostitution circulated at the time.

It is not surprising, perhaps, that Hotel Marie is another place for ghosts to hover downtown. A local psychic has sensed spirits at the hotel and feels it is due to violence in the 1930s and '40s connected to poker playing. Gambling and drinking were rife in the area at the time, with speakeasies offering illicit liquor along Harrison Avenue.

MILLIE

A visit to downtown Panama City is not complete without a visit to Millie's for a cup of coffee accompanied by a beignet and a chat with the owner, Dave.

Number 224 Harrison, which now houses Millie's and a clothing store, used to be known as Sherman's Arcade after local businessman Walter Colquitt Sherman. He bought the American Lumber Company in Millville in 1919 and renamed it Saint Andrew Bay Lumber Company. During his time in town, he operated a fishing fleet, an ice plant, a shipyard, a machine shop and a store and was the director of the First National Bank. He was also an officer of the Atlanta–St. Bay Railway. An exceedingly busy man, he helped organize the Panama City Chamber of Commerce and served four terms as president.

Sherman developed many amenities in the town, including the golf course at Lynn Haven and the Sherman-Dixie Hotel. This hotel was razed in April 1970 with the help of a six-ton wrecking ball. It was a sad day for many, as this had been Panama City's only skyscraper and part of the history of the town since 1927. It was a grand place with a beauty shop, rooftop garden and mezzanine. Harry Houdini's wife, Bernice, stayed there in 1937. She tried not to be recognized, as she didn't want people to accost her to talk about ghosts, in which she no longer believed. She had famously spent years looking for ghosts and trying to communicate with Houdini's spirit, to no avail. She came to the conclusion that ghosts only exist "in the minds of people who want to believe." Harry Houdini had promised to contact

her from the other side with the code phrase "Rosabelle believe." Bernice was certain that if anybody could get through from another dimension, it would be her escapologist husband. He had spent much of his later years discrediting mediums and spiritualists, including the well-known Mina Crandon. An early ghostbuster, he would attend séances in disguise along with a policeman and a reporter.

The Sherman Arcade was built in 1934 for $20,000. It boasted a ten-foot arcade, an architectural term for a series of adjoining arches, with two ground-floor rooms and thirteen offices upstairs. The *Panama City Pilot* of July 12, 1934, declared it to be "a distinct need in the city at this time."

Sherman himself used office number nine on the second floor. Other offices included a dentist, a lawyer, investments, a shipping line, contractors, insurance and Girl Scouts. Retailers included a newsstand, a beauty shop and a clothing store. At a later time, it housed WMBB TV studios. Latterly, it has been home to four different restaurants, with the upstairs rooms being let out as apartments. The building has had many uses, and many people have passed through its doors. Not surprisingly, it is reputed to be haunted.

Many strange phenomena took place over the thirteen years WMBB TV studios occupied the building. Employees heard footsteps upstairs when no one else was in the building, file drawers would open and close at random, staff would frequently report an eerie feeling of being watched and phones would ring after hours even though they had been disconnected for the night.

During the 1980s, a man committed suicide by hanging from the rafters in the arcade. It has been said that his body can be heard swaying backward and forward on windy nights. When Gladys Grimsley and her team of ghost hunters from Capstone House investigated the building, they saw an old black man wearing jeans with a bib. He was barefoot and sitting on the stairs. His clothing and melancholy air led them to believe that they had seen the ghost of the suicide victim. Orbs and strange shadows were noted too.

While the ghost hunter team was sitting in the restaurant, they noticed an older lady and a gentleman in a sea captain's outfit sitting talking at the bar. The couple had not been there when the team arrived, and they disappeared mysteriously not long after. Dave believes the gentleman was his great-uncle Dave Maddox. He was a sea captain in World War II and used to ferry troops to Europe. He also helped guide ships through the narrow channels of the bay to safe harbor. Captain Maddox led USS *Ironsides* to dock from Port St. Joe. The lady was possibly Dave's mother and the captain's niece, Millie. She was wearing Millie's favorite colors of pale blue and white.

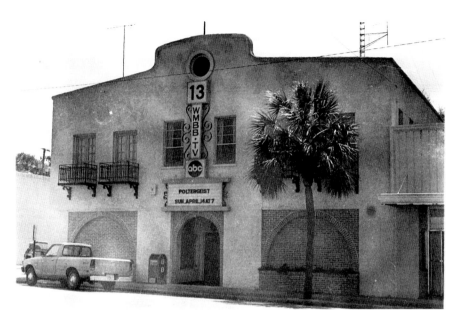

Old WMBB. *Courtesy Bay County Library.*

Millie's ghost has been known to make other appearances around Panama City. Millie owned a 1994 Pontiac Grand Prix, only eleven years old with seven thousand miles on the clock, which Dave inherited after Millie's death. He sold the car to a friend who worked at a grocery store nearby. Shortly after he parked his Pontiac and went into work, someone came into the store and asked him about the old lady sitting in his car. Of course, when he went out to look, the car was empty. The observer's description of the lady matched Millie to a T: gray hair, wearing white and clutching the steering wheel tightly while hunched over it, exactly how Millie used to drive. In life, she had loved that car and made sure that Dave washed it weekly. She was no doubt checking it was in good hands.

In the corner of the restaurant is a rectangular picture showing a stretch of street near Pat O'Brien's in New Orleans. Another street sign reads "Millie's" in just the same font that Dave and his wife, Barbara, chose for their menu. Neither of them remembers seeing this sign in the picture. Unless this information passed to them subliminally, it is a very strange coincidence.

Another haunted team of paranormal investigators visited Millie's. They mentioned to Dave that two words had come up on their equipment: DOG and DAILY. A few months earlier, Dave had his beloved dog, Daily, put to sleep.

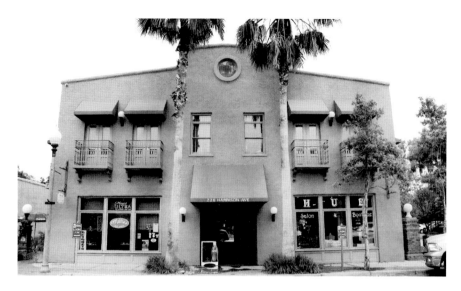

Millie's.

Dave also mentioned a large rack of spoons behind the bar that have been known to fly off the rack of their own accord. One day, Dave's wife called him behind the bar to witness a strange phenomenon. Out of the five spoons on the rack, only the middle one was in motion, swinging as the other four spoons remained still. Dave put out his hand and said, "Enough's enough, Mom," and the swinging ceased. Millie was no stranger to the building, as she used to work upstairs for a lawyer who later became a judge. Perhaps she is checking on Dave or revisiting old haunts.

On another occasion, a customer was leaning against the bar, chatting with his arms folded. He was wearing a leather bomber jacket. All of a sudden, his sleeve was lifted up as if pulled by an imaginary hand with enough strength to move his arm.

One spring evening, Dave and Barbara locked the doors and were sitting outside before leaving for the night. Looking back, they saw a woman inside walking toward the window. She peered out for a second before walking toward the back of the building. Amazed that they could have left someone inside, they reentered the restaurant, but no one was there. I like to think it may have been the Lady in Blue from Belmar Antiques a few doors along, or more likely, it was Millie again.

Having finished my coffee and had a great chat with Dave, I was about to leave as a customer approached; his name, believe it or not, was Ghost, proving that ghostly visitors of all types enjoy the hospitality of Millie's.

THE LADY IN BLUE

Psychometry—the ability to discover information about an event or a person by touching objects associated with them—has long intrigued me. Many people believe that we imprint part of ourselves on everything we own, as well as the very walls of our houses. If this is the case, how likely might it be that an antique shop would be full of souls attached to valuables or items they were sentimental about while alive?

When a paranormal team investigated Belmar Antiques at 306 Harrison Avenue, they found it to be one of the most active places for spirits so far in the downtown area. A reporter from the *News Herald* who was writing an article on the paranormal was there during the investigation and managed to take a picture of a Lady in Blue. Meanwhile, much activity, such as shadows, swirled around her with increasing intensity and strength. Old photographs suggest that the building was a garage in days gone by. There is no evidence that anything untoward happened here to account for a haunting. The preferred theory is that the Lady in Blue is attached to an item in the shop. She may move on if the item is sold.

More supernatural activity has taken place here. Items have moved, light fixtures have crashed to the floor and a misty apparition was recorded floating past a display case. A *News Herald* report in October 2015 mentions a set of Jacobean high-back chairs for sale in the store. Previously, they had been in a bedroom in the owner's house. One night, a family friend awoke to see an apparition sitting in one of the chairs. Scared to go back to sleep, she stacked the chairs in the closet.

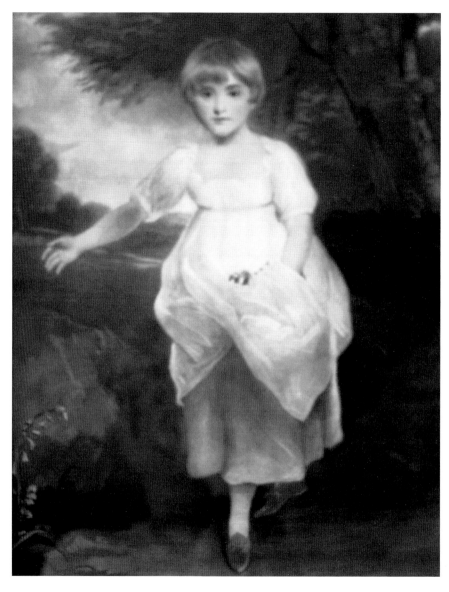

Miss Cholmondeley.

Elegant Endeavors Antique Emporium at 551 Harrison Avenue is one of my favorite stores. It has a wealth of curios, bygones and antiques spread over two floors. All sorts of things can be found here, from vintage Italian mosaic pins to Beatles LPs. My most intriguing find was a print of a little girl. I had been looking for something else entirely. However, I kept passing

the picture, and she seemed to stare back at me, asking to be bought. On inquiring about the price, I decided to buy her. Reaching home and looking at the back of the print, I discovered she was called Miss Cholmondeley (pronounced Chumley). Further delving led me to discover this little girl had lived in the same small village in England where I grew up. What a coincidence—both of us so far away from home in the same small town across the pond!

Elegant Endeavors has also had items moved. Some shoppers were more than a little surprised one afternoon when pieces of china flew off a dresser without anyone near enough to have disturbed it. Although the owners, Debra Anderson and Jane Lindsey, have not seen anything ghostly themselves, customers have reported a "rugged sea captain who makes the front staircase his regular haunt, the specter of a lady in white in a back corner of the expansive store or a young girl crying because she wants something from a glass case," as quoted by Eryn Dion of the *News Herald*.

THE GILBERT BUILDING

What a varied history this building has had, and with so many people through its doors, no wonder some have returned to haunt it. From nearby murders to sums of money both large and small, lost when it was a bank, there are plenty of motives for ghosts.

Back in February 1884, G.W. Jenks bought the land on Harrison Avenue from Samuel J. Irwin. The building was erected in 1903. It is the oldest brick building in the area, as well as one of the oldest buildings period. Originally three stories high, it suffered fire damage in 1945. It was rebuilt with original bricks but without the top story.

In 1908, it became a bank founded by George West, the founder of the *Panama City Pilot*, for $15,000. He used an upstairs room for the paper before moving to St. Andrews Publishing House. George West was bank president, A.T. Gay was vice president, Oscar McKenzie was a cashier and Ms. Brown was a bookkeeper. The first telephone in the area was located upstairs.

Also upstairs was a dentist's office belonging to Dr. Puicin from 1910 to 1915. Early dental methods might have been enough to cause a haunting, I expect! From 1917 to 1924, there was a café downstairs and then for the next six years Suddith Realty. In the 1930s, two doctors had a practice here, and Bynam's Barbershop operated from this building, along with a judge's office, a post office, an attorney's office and another dentist. What a busy place Bank Corner must have been.

In 1942, the Gilbert Building was home to the Bay Shine Bar. This was remodeled in 1974 and became La Royale Lounge, which has only recently

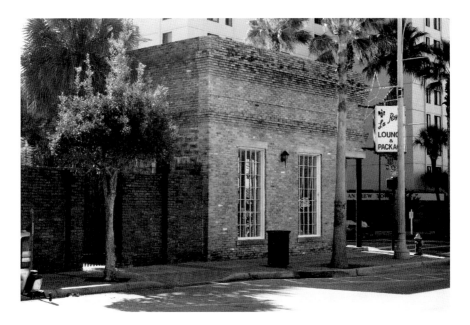

The Gilbert Building.

closed. Staff frequently reported all types of paranormal activity in this building: feeling icy-cold breath on the backs of their necks, as well as hearing clinking glasses, rattling ice cubes, footsteps, doors slamming and muted conversations. Some workers refused to go into certain rooms alone due to an overwhelming sense of dread. This may be due to the suggestion of La Royale being a house of prostitution in the 1950s. Girls were paid so little they became trapped and unable to leave and were perhaps even stuck there in the afterlife. Apparently, many girls died from abortions, overuse of diet pills, cocaine addiction or being pushed down the steep stairs in the Fiesta side of the building.

Gentlemen who may have a reason for haunting this building include Dr. Daniel Adams, who established the first hospital in Panama City in 1924. When the bank crashed, he lost all his cash savings. A year later, he committed suicide for "reasons still unknown."

W.C. Sherman, the principal chair holder and chair of the board of the First National Bank, lost $250,000 worth of stock in the Panama Bank—a large sum of money by today's standards but a huge amount in the 1930s. Ms. Loftin wrote at the time and was later quoted in the *News Herald* in 1984 as saying this was "because the bank president had apparently made too many loans on faith, and faith provided meagre collateral in 1931."

Joseph Mullins, owner of nearby Mullin's Grille, was murdered and decapitated in 1942. The perpetrator of this crime has never been found. Also, hardware owner Roy Van Kleek, who had his shop across the street from the Gilbert Building, was brutally shot and killed in his parking lot. Justice was meted out for him, as explained in the chapter "Old County Jail."

So many potential ghosts to choose from: working girls, Joseph Mullins, Dr. Daniel Adams or a very dissatisfied client of the dentists, doctors, judge or barber. Or perhaps George West returns to mourn the collapse of the bank he founded.

CAFFIEND'S 247

This dark and rustic café is full of interesting curios, wonky floors and specialty foods—a pleasant change from the usual chains where coffee can be ordered. The "247" of the name indicates the shop is open all hours, or "24/7."

Found at 439 Grace Avenue, the café's archways and balcony lift it from the harsh rectangular lines of nearby buildings. On the corner of Jenks Avenue and Fifth Street lies the former site of the *News Herald* before it moved to Eleventh Street. The owner of Caffiend's, David Hayes, believes there was some connection with his building and the paper by way of printing equipment.

Hayes has always found the rooms he now occupies somewhat strange and eerie. Working here, he has noticed definite cold spots toward the back of the building and late at night has heard footsteps in an adjacent room when no one has been on the premises. Most curious of all is the latch to a small pantry that manages to open itself despite being securely fastened. More than once, Hayes has fastened the door, only to return shortly afterward and find it not only unlocked but open.

According to ghost hunters, this whole area near the post office and old site of the Dixie Sherman Hotel is worthy of more investigation. The murder of local restaurateur Joseph Mullins, who was separated from his head near here in 1944, could well be cause for haunted activity.

It was a chilly February night when Joseph Mullins left his all-night café Mullins Grill, boasting that he had won $112 gambling. His wife, Hazel, was not worried when he failed to return home, as he often spent the night at

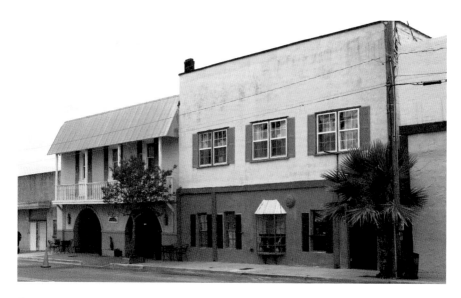

Caffiend's 247.

the café, working, gambling or talking to business associates until the early hours. Hazel's concern began when he didn't appear the next morning and escalated when she found his bloodstained Chevrolet near the post office on Fifth Street when she went to check the mail for the second time that day. Hazel was hoping to receive a photograph of her brother, who was stationed in England at the time. The 1941 light blue sedan had not been parked there during her earlier outing but by 3:00 p.m. was in the very same spot she had visited earlier.

A few days later, Mullins's decapitated body was found in a wooded area near Tenth Street and Buena Vista Boulevard. On examination, it was clear that excessive force with an axe or meat cleaver had removed his head. To this day, the head of Joseph Mullins has not been found. Three individuals were taken into custody, but none was prosecuted. There was scanty evidence against them, mostly of a circumstantial nature, and there was no sign of a murder weapon.

A suggestion is that it was a robbery, as his wallet was missing; another is that the gambler he won money from was so angry he killed Mullins in the car and then took the body to a secluded spot and removed the head to make identification more difficult. A *News Herald* article in 1959 suggests Mullins had been active in underworld politics in Alabama and associates wanted him dead. The head was needed in Phenix City as proof of the gruesome deed. Perhaps the murderer mailed it from the post office!

JINGLE BELLS

Harrison Avenue downtown is the home of much ghostly activity. Many of the old buildings have basements, and rumors abound of tunnels stretching across the street. These were built in the days of Prohibition, when rumrunners, speakeasies and skin games were, literally and figuratively, underground.

Between 1920 and 1933, bootlegging—the transportation of illicit liquor—was rife. Inlets and bays nearby were excellent secret landing places for pirates and rumrunners. Panama City was not far from the Caribbean islands, where liquor could be bought cheaply and easily. In case they were caught by the coast guard, captains devised various methods to disguise their cargo. False bottoms concealed liquor and, at the pull of a lever, could be opened to dump the bottles into the sea if the authorities approached. Another invention was a long metal tube called a submersion tank. This was chained underneath the ship and filled with rum. If need be, this container could be untied and cast adrift to avoid detection.

Speaking with Erin, who used to work at 437 Harrison Avenue when her mother owned the store, I was intrigued by the many strange occurrences she experienced. The store, then as now, was an antique shop. Previously, the building was used by JCPenney.

The back door had a layer of tinkling bells attached so that Erin could tell if her mother entered that way later. The door led into a basement used as a storage area, referred to as the dungeon.

One morning, having entered the building by the back door and locked it, Erin was in the dungeon turning on the breakers for the electric lights when she heard the bells jingle. Although not expected that day, she wondered if her mother or a vendor had entered the building. They were the only people to have a key. She called out, but no one replied. Erin checked later, but none of these people went near the premises that day.

From the counter, staff could see both doors, and they would sometimes notice them mysteriously open and shut, even when there was not a hint of a breeze in the air.

An office was located in the upstairs gallery. Erin would often hear the sound of footsteps emanating from this area. She would also catch sight of shadows out of the corner of her eye; on turning, there would be nothing to see.

Most of these phenomena happened during Erin's first year in the store. Perhaps she ceased to notice, or maybe the ghosts became used to her and bothered her less.

Erin now works in another antique store across the road, Estate Treasures. She finds it far less eerie. Only once did she hear the distinctive grating sound of the door opening on its own one night.

BAYOU JOE'S

It's a cloudy February morning, but it is still very pleasant to sit by Massalina Bayou in one of Florida's few remaining mom-and-pop restaurants, Bayou Joe's. The food is delicious: a plate of "garbage" (chef's choice of seasonal or leftover food) coupled with a "Killer" Bloody Mary.

Massalina Bayou, previously known as Slade's Lake and Harmon's Lake, was renamed after Spanish trader Jose Masslieno. Jose was a free Spanish black merchant marine. In 1836, he traveled to Georgia, where he bought a slave wife and invited forty families to return with him to this area to build a school, a church and homes. He built a homestead at Redfish Point, which became Tyndall Air Force Base in 1941 when the government took over the land, forcing the homesteaders to move across the bay to Massalina Bayou. Jose's son Hawk "Nabisco" Massalina was a well-known resident and boat builder who helped people to hunt and fish. Hawk was convinced that pirate treasure lay buried at Redfish Point, hidden there by Spanish galleons and buried between two trees. No treasure has been found, but many locals believe it may be awaiting discovery.

The Massalina Marina downtown is now the oldest working marina in Panama City, dating back to the 1940s. At that time, there were gas pumps for fueling, and many old fishermen sat and watched the boats come in, discussed fisherman's tales and drank a beer or two. The restaurant, then owned and operated by a colorful figure called Old Man Etheridge, had no liquor license, so the beer was "free" but paid for later under the counter. The fishermen would see to their nets and watch the mules pull the dories

Narcissco "Hawk" Massalina.
Courtesy Bay County Library.

out of the water so that they could be cleaned and repaired.

The restaurant had a candy store attached to the side. Fathers would leave their children on the dock when they went fishing and settle up the candy bill with Old Man Etheridge upon their return. The dock was known as Etheridge Marina in his day. Before that, it was called the Dock at J.R.'s. The "J" in J.R.'s and in Bayou Joe's refers to Josephine, a cook with a temper. She was known to hit people who annoyed her with a spatula!

The present owner, Kevin Shea, is the eighth person to own this property. He has kept the old-world charm, photos of past times on the walls and the great eating experience. He has added some underwater lighting, giving the water a green and eerie glow at night. Children are eager to feed the fish and enjoy watching them glide through the dimly lit water at the edge of the dock.

Kevin and wife Jennifer had heard rumors of ghosts at their newly purchased restaurant but chose to be skeptical until they, too, saw the specter. One evening when Kevin stayed late to clean up after everyone else had gone, he suddenly heard the side screen door open and shut from across the empty restaurant. When he emerged from the kitchen, he glimpsed a figure out on the deck—an old man in a yellow fisherman's slick suit—but when he went out to look closer, no one was there.

The figure of the old man usually appears late at night or early in the morning when few people are about. However, he has been spotted on numerous occasions by various people over recent years. He causes no harm, but goose flesh always rises on the arms of onlookers.

One theory is that the ghost is of William Augustus Farley, alleged to have drowned in the bayou. His gravestone in an Apalachicola cemetery does say he was "lost at sea" and died on April 17, 1870. I have found no other evidence to uphold this claim. The cook and waitresses at Bayou Joe's maintain that the ghost they have encountered is more likely that of Old Man Etheridge, checking that his beloved restaurant and marina are still running smoothly.

ROGER

Julie Gordon spent many years with her ex-husband, Larry, at 511 Massalina Avenue. As soon as Julie first saw the house, she knew there was something unusual about it; the place called to her. Or perhaps it was the poltergeist in residence she was soon to meet, Roger, wanting company from someone who would understand that he was stuck and sad rather than scary.

Shortly after moving in, Julie and her family noticed something strange going on in their new house. Doors would slam and electrical items would go on and off, and one day when two brothers were arguing over the stealing of a slingshot, the door blew open and the lost catapult was thrown onto the floor in front of them. The mysterious apparition, which they came to call Roger, would whistle or snap his fingers as he moved around the house. Although Julie did not mind living with a poltergeist, her children were never keen to stay in the house on their own. Others would be scared away, as the ghost was a showoff and happy to play tricks when people were about.

Apparitions appeared regularly. Legs were seen and heard going up the stairs when only one person was at home. Roger could be flirtatious; if girlfriends visited, he would brush their hair back from their shoulders. He liked to hover downstairs and would sometimes place his hand over the top of someone's hand as they tried to turn on a light. Julie and Larry were so intrigued by this that, to find out more, they installed meters, lasers, lights and motion detectors throughout the house. Every night, they would hear the sensors bleep and would say, "Goodnight, Roger."

Number 511 Massalina Avenue.

Curious about their new housemate, the Gordons consulted a Ouija board to communicate with the spirit. The story they received was tragic. The Gordons' house is on the bay, and Julie believes this is where Roger drowned at age seventeen, murdered by his boss from the fish house that used to be on the property, possibly for witnessing some unscrupulous behavior. Roger's family believed he had moved on to newer pastures, as this was the yarn the family friend and manager told them. Of course, his family never saw Roger again or knew the truth of his untimely demise.

Julie's sons used to return from the shed and ask who the wet boy was looking at them. Some nights, Julie and friends would walk toward the water and notice evidence of footprints in the leaves, as if steps were coming toward them—three or more, then they would fade. Sometimes a full-body apparition would be seen. Julie remembers this clearly as the most frightening of all.

Roger became a part of the family. Sometimes he was helpful and would open cupboards and place the peanut butter on the counter. He could turn the knob on the television, and the light switches might visibly move up and down. He was powerful enough to move the strings on a guitar. He would enter photographs as orbs. Having had his head held under water for so long, Roger is stuck in this dimension and time, as

Massalina Bayou.

I expect he was by no means ready to leave the earth when and how he did.

Julie was also aware of a female presence, Sarah, a small girl who used to run through the dining room trailing the scent of jasmine behind her. Before the Gordons moved in, images of tiny handprints could be seen on the wall and ceiling in the dining room. However often they were painted over, they returned. Julie believes Sarah died of yellow fever and returns to play in the yard.

THE COVE

For thousands of years, Indians roamed the land of North America. The Gulf Coast was no stranger to Indian activity, and many pot or burial ground mounds have been discovered along the shores of Bay County, Florida.

The Cove, one of the earliest areas of Panama City to be built on, has Indian evidence both in artifacts found and ghost tales told. Ann Robbins, a longtime resident of the Cove, told me of the night she heard voices mumbling in her hallway. It was more than one voice, but she could not make out what was being said. She woke her husband, fearing someone was in the house. They went along the hall, but no one was there. Deciding she had been dreaming, she returned to bed and sleep. A few weeks later, Ann heard the voices of at least three men talking. She heard them discussing together on at least six different occasions. Ann's daughter heard them once too and thereafter was not keen to stay in the house. However, the voices have not been heard since the piano was sold. A coincidence, perhaps, as it is hard to draw a connection between braves and pianos.

Ann had no pets and ruled out noise from the furnace or anything electrical. Her research suggests that Indians camped in what is now her yard over one thousand years ago. She has found pieces of a pot that has been identified by an expert as dating to the period of the Fort Walton Indians.

The tree-lined streets with interlacing branches of Spanish moss lend this area of Panama City a unique and slightly eerie feel. It is little wonder that some of the old houses here have ethereal and inexplicable visitors. Nina

Spanish moss in the Cove.

lived in a house that used to belong to her aunt. In this house is a very friendly ghost. Nina felt that she was hugged from behind on one occasion when she was checking on her children as they slept. On turning, no one was there. New owners have heard the tales of this ghost, assumed to be the aunt, but have not met her yet, although doors seem to open and shut of their own accord.

GRANDMOTHERS RETURN

Two people I met during my haunted story research in Bay County Library had ghost tales to tell of seeing their grandmothers appear after death.

Ann Robbins was four years old when her mother, Pauline, woke and told her about a dream she had just experienced. She had seen her own mother, Ann's grandmother Bessie, in a bedroom she did not recognize. She was in the bed and dying.

A day or two later, a relative from Panama City arrived in Port St. Joe, where Ann and her mother lived at the time, and told them that the grandmother was dying. She was visiting relatives in Vernon, Washington County, when she began to feel unwell. Bessie was a devout woman who prayed daily and claimed to have seen an angel at the foot of her bed.

Pauline and Ann set off on the worrisome seventy-two-mile journey through Panama City heading north to Vernon, and sadly, they arrived too late to see the grandmother alive. However, the bedroom, the iron bedstead and the way the lady was dressed were the same as in Pauline's dream. All her brothers and sisters were there except for Pauline, and the grandmother had been calling for her. This was not a house that Ann's mother had ever been in before.

The next strange occurrence occurred a short while later, after Ann and her mother moved to Third Street in Springfield close to the paper mill, scene of the Martin House hauntings. Ann was in the bathtub. Then both Ann and her mother heard the grandmother's voice calling, "Pauline."

They both knew it was the grandmother's voice and that she was somehow saying goodbye.

Some weeks later, I met Richard in the library. He told me of a time when he was twenty and he and a friend liked to visit cemeteries to feel that eerie, scared feeling. It was the night of a full moon in the summer of 1970 when he walked through the Lisenby cemetery on the corner of Lisenby Avenue and Fifteenth Street. This is where his grandmother Annie Lee Raffield was buried. Suddenly, he saw her. She was misty and faded, not solid like a living person. He knew it was her from her short stature and because she was wearing the white gown that had been given to his mother for Annie to be buried in.

GLADYS REMEMBERS

Eighty-eight-year-old Gladys Grimsley is to be found most days at Capstone House, a spiritual center at 1713 Beck Avenue. She has lived in Panama City since her twenties, when she, her husband and her eight-year-old son moved here from Georgia to start a new life nearer the sea.

Gladys has belonged to a group of ghost hunters in Panama City for many years. Her first ghostly experience, however, was at age thirteen in Georgia. She had always found her childhood home eerie and would sit on the front porch if alone rather than remain inside. On one occasion, she felt a hand on her back and a voice spoke, "I will not harm you, don't be afraid." Previously, a lady had been killed in the house by her husband. Gladys believes this was the woman's spirit. One night, her mother saw a vision of this spirit glide across her daughter's bedroom.

The scariest moment Gladys has experienced so far in her years of investigating the paranormal is being thrown across a room in the house of a Louisiana judge. Myrtle House is a plantation home where many ghosts reputedly linger and at least one murder and many deaths occurred. A friend witnessed Gladys being thrown across the room, and people outside heard the thud as she hit the wall.

Gladys has discovered many ghosts in and around Panama City. Opposite Gulf Coast State College near the Hathaway Bridge, there was a barman named Mr. Ed. The ghost hunters took his photograph as he stood behind the bar. On developing this picture, there was a superimposed photo of a

lady with long blond hair over Ed's hair and a long-sleeve blouse over his arms. The group interpreted this as a possible past life of Ed's. I believe this location may have been called Jersey Lilly Saloon or possibly Confetti's Nightclub; it was called various names over the years. According to Haunted Places website, patrons reported objects being thrown at them or moving around of their own accord, and some even saw a wispy apparition. Much activity centered on the bathrooms, where "violent" noises were sometimes heard and the toilets might flush on their own. Perhaps customers had one drink too many and dehydrated in the heat of Florida. Was it spirits or *spirits*, one wonders?

A friend of the ghost hunters owned a restaurant on Beck Avenue. One evening as the group entered a back room, they walked in to refrigerator-cold temperature. All the sonar equipment they had with them turned red, and a girl's voice frightened them by saying, "Come here. Come here." The girl told them she was lost; it was raining and she couldn't find her mother. Gladys took her hand and persuaded her to step through the light in the corner of the room to join her mother. Instantly, the room warmed up. The cat, Elvis, was not so pleased; the girl had been his play mate, and he meowed continuously for some while after she left.

Cemeteries are a popular place for ghost hunters. According to Gladys, the Millville Cemetery to the east of Panama City has a heavy energy. She senses "scary stuff" in this location. Five investigators were in the group one night when they heard footsteps behind them. Announcing aloud that they would take a photograph, they all turned to do so, but nobody's camera worked. The flashbulbs were out for the whole group, only to return for all five minutes later. "Be careful what you say," warns Gladys.

Capstone House has been on Beck Avenue for twenty-five years. Previously a church, it is now a spiritual center, with Gladys as director for the last sixteen years. Before the present building, there was a family home here. Gladys will catch a glimpse into this other world on occasion. Sometimes she sees a large wooden door near her office. She refers to it as "a sad door" that is no longer there.

One day, Gladys was in the main part of the building, formerly filled with pews, when she witnessed a small girl running around and around and in and out of the chairs. She had long blond hair with a bow, patent shoes and a pretty blue flowered dress. She ran up to Gladys and smiled before disappearing. She is often close to Gladys, sometimes touching her. Others at the church have seen both the girl and a young boy in the building.

GRACE AVENUE

Grace Avenue is a beautiful old street in the heart of Panama City. The homes here are old and graceful; most will have a story to tell. In Ernest Spiva's book *Growing Up on Grace*, the author's memoir about growing up on this street, he talks of the close-knit community that existed here in the 1940s. The avenue was named after the daughter of a pioneer settler and was "the site of many grand homes of early community leaders." The pavement ended at Eleventh Street, just a dirt road at the time.

At 918 Grace Avenue is a house referred to as Haunted Manor.

"Cold bursts of air, voices of people you can't see and extra shadows on the walls," writes Jessica McCarthy in the October 31, 2011 edition of the *News Herald*. "Rooms fill up with the smell of cigars and pipes, lamps turn on and off by themselves and fans blow without warning."

Pots and pans used to fall out of cabinets at the same hour each morning, according to a previous owner; children used to see the figure of a man passing through rooms, and the eldest son, Aaron, a teenager at the time, looked up from the backyard to see a ghostly shape of a man in an upstairs window. Once he appeared to an adult. The owner of the house, Michael Smeby, was relaxing in the bathtub when he noticed a semi-transparent figure. "He was short, with sandy brown hair wearing a tannish turtleneck, a jacket and brown pants," quotes Tony Simmons in the *News Herald* in October 1993. No doubt it was quite a shock to see an apparition in the bathroom doorway.

Haunted Manor, Grace Avenue.

The family installed motion sensors, which would regularly be set off at night. There were no pets or intruders to disturb them, so this became a nuisance and they were removed.

Simmons continues with the tale of the ghost becoming more violent and targeting Aaron. "A window crashed down on him, and he once was pushed off the rooftop of the porch by 'invisible hands.' Lying in his bed one night, he was tapped several times on his back as though being poked by a finger. Then he felt hands on his legs and feet."

The owners did not feel afraid to live here but may have felt apprehensive after rogue spirits tried to burn down the house. The family was sleeping when the fire started. They all got out safely but discovered the cause of the fire to be the turning on of a heater that did not have electricity connected.

Also on the corner of Grace Avenue, opposite the Cola Plant, is the plot of 515 Oak Avenue. All that remains of the house is the stoop and a few steps. Minnie Lee Pumphrey used to live here until her death. Her granddaughter Jeanette was alone at this house soon after her grandmother's passing. Jeanette was lying on a couch when she looked up and saw her grandmother sitting in her usual chair and looking out the door. She glanced at Jeanette, smiled and disappeared.

Another ghost to smile at Jeanette was the Bay County High School bandmaster, Orin Whitley. He died of a heart attack in 1955. Jeanette was practicing in the band room a few weeks after this sad event when, to her surprise, Mr. Whitley appeared to her in the doorway and grinned.

Bay County High School is not a stranger to unusual stories. Elizabeth Temple Burroughs of Panama City tells the following tale in an October 1997 issue of the *News Herald*:

> *Our story begins at the Bay High School prom. A pretty senior girl leaves the beautifully decorated gym to powder her nose in a nearby restroom. Suddenly, above the music and many laughing voices comes a heart stopping scream from the direction of the restroom.*
>
> *As the students and chaperones rush in to the restroom to see what the trouble is they are shocked at what they find. A pool of blood, but no body. Where had she been taken? Who was she?*
>
> *Her name is Mary Worth, but what happened to her body was never known, and her killer was never found.*
>
> *Local stories tell us Mary Worth still walks the halls of Bay High School, turning on and off the lights and turning on the water in the home economics room. We are told after school Mary walks the halls in the after-school stillness.*

No one has evidence of Mary Worth at the school or how this rumor started. Elizabeth notes the supposed ghost shares the name of the famous cartoon character created by Martha Orr in 1932.

THE WATCHMAN IN THE WINDOW

Hannah House was built around 1886, according to some sources; others put it earlier, with deeds dating to 1858. The house sat on a bluff overlooking Saint Andrews Bay. Hurricanes and later buildings have disrupted this magnificent view, although the water can still be seen from upstairs windows.

Back in the early days of the house, women would gather on the third floor and look out to sea. From this vantage point, they were able to spot the fishing boats returning and knew when to start preparing supper. Some decades ago, a small girl was visiting the house with her mother. On descending from a look-around upstairs, the girl said the man on the third floor was "so nice" and wearing a blue uniform. There were only three women in the house at the time. A ghostly apparition has been noted to appear in the third-floor window. Perhaps it is the spirit of a Civil War soldier, checking to see if the coast is clear.

Recent owners have not noticed much by way of haunted happenings. They have heard odd noises, but this is hardly unusual in an old house. Once, the lady of the house awoke with a feeling that someone was suffocating her. However, this can be explained by sleep paralysis, which occurs when a person feels conscious but is unable to move during sleep. It happens when transitioning between a wakeful stage and full sleep. A stranger occurrence is a pair of small moccasins that have moved to another place when no one is home.

Hannah House.

A salt kettle.

There is a strong possibility that the house next door was a hospital during the Civil War. A few steps from this house is a historical marker that tells of the St. Andrew Skirmish. On March 20, 1863, Confederate soldiers under the command of Captain Walter J. Robinson repelled a landing of Union soldiers led by James Folger of the blockading vessel USS *Roebuck*. During the skirmish, several Union soldiers were killed or wounded. The battle was bloody and of strategic importance, as the Union blockades were trying to prevent salt from entering the Southern states. Salt was a very important commodity in the days before freezers; not only did it flavor food, but it also prolonged the food's shelf life when cured. Necessity being the mother of invention led to salt kettles appearing along the Gulf coast to make use of the plentiful supply of salt from the sea. Many Southerners helped with the process of boiling the sea water until it evaporated, leaving a thick, salty solution that continued to dry out in the Florida sun.

CLEOPATRIE

The late Bill Tant of Panama City told his ghost story to the *News Herald* some years ago. It can be found in an undated article in the ghost folder at the Bay County Library. The editor's note says this and other tales on the page are "real life" ghost stories submitted by readers. His story begins:

It was a bright clear summer night in the year 1920 as I gazed out of my window at the docks of St. Andrew. Everyone was long asleep in the house except me. From out of the dark came this all white, two-masted sailing ship. It docked, and I sat up in bed, as I never seen such a magnificent ship. Suddenly a light lantern appeared and whoever carried it paced up and down the dock. My 13 year old curiosity got the better of me, so barefoot and all, I jumped out the window and headed across the road to the docks.

Walking quietly, I approached the moving light and vessel when I heard a splash. I ran to the end of the dock, looked down into the dark bay water and saw ripples, but no one was in the water. At my feet was the burning lantern, a mariner's blue coat with brass buttons, a pair of blue pants and high top boots. I paced back and forth on the dock beside the boat searching for a body in the water. After what seemed like hours, I gathered the clothes and went back home. Waking my dad at 3:00 am meant trouble for me, so I quietly slid back to bed. When my eyes popped open next morning, I dashed to the window but the ship was gone! I ran to my dad's room and

told him what I had seen, but he didn't believe me until I showed him the clothes that I had found on the dock.

"Why son, this is an ancient mariner sea captain's suit. Did you get the name of the boat?"

I said, "Yes, Papa, it was the Cleopatrie.*"*

"No son you mean Cleopatra,*" he said.*

I spelled it out for him as it was written on the bow of the boat. My story fell on deaf ears for many years until Fred Williams of St. Andrew told me of a boat named Cleopatrie. *It sunk off the shores of Hurricane Island in the late 1800s.*

Maybe it was, in fact, a ghost boat. Then again, maybe someone was trying to tell a young thirteen-year-old boy of St. Andrew something. But why? This ship was probably French, and Hurricane Island, where it sank, is off the coast of Maine. A more likely explanation to my mind is that the ship was the *Cleopatra*—the very same that Andrew Martin was on when he drowned in a storm much nearer to St. Andrews in 1909.

A more likely ship to make a ghostly appearance in Panama City waters is the USS *Tarpon*. After a record of 1,735 trips, this ship met a tragic end

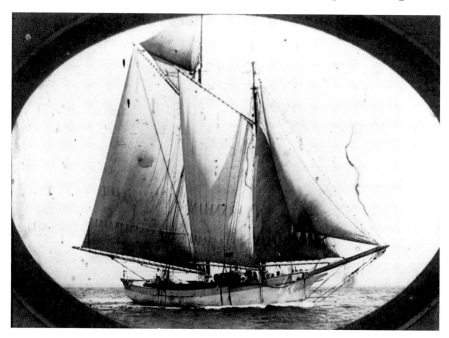

The *Cleopatra. Courtesy Bay County Library.*

on September 1, 1937, when stormy weather caused it to sink and drown nineteen of the thirty-one people on board.

A hurricane in 1894 is responsible for a ship sinking in East Bay, drowning sixteen young fishermen. They knew a storm was brewing but were confident they could catch enough mullet to feed their families and be back before the storm broke. The hurricane arrived early, and despite their attempts to tie the three schooners together, the *Annie, Lizzie B.* and *Arrow* broke loose and were seen bobbing about in the bay by the lighthouse keeper. Rumor speculates that the cries heard on windy nights are those of the boys who never returned. "The Lost Boys of East Bay" is a ballad reputedly written by Harry Evans in 1894:

There's a story so sad I'm about to relate,
Of a ship that has left here and gone to her fate,
Of the fatherless children and the mothers who wait,
The news of their loved ones and their hard cruel fate.

The chorus:
Oh, your hearts will turn towards them in pity, I know,
When the surf beats loud and the stormy winds blow.
Let their friends look towards Heaven, where their spirits today
Look down on their sad homes on the shores of East Bay.

'Twas the year '94 on an October day
They sailed from their homes on the shores of East Bay
Not a thought of their fate as the farewell they say
As each kissed some loved one and sailed from the bay.

But the saddest of all in the tale I now tell,
How the storm swept the island like the furies of Hell,
How each raging sea left its victims that day,
Those sixteen brave lads from the shores of East Bay.

Oh that mother who's left without husband or son
To cheer her at evening when the day's work is done.
But those kind hearted men will go out never more,
In struggle to drive the grim wolf from the door.

THE OLD BANK AT ST. ANDREWS

Nestled comfortably at the corner of Beck Avenue and Tenth Street opposite the beautiful park Oaks by the Bay sits Bay County's oldest bank, Bank of St. Andrews. According to the historic plaque outside, the bank was established in 1907 with a starting capital of $15,000 and six directors. One of the six was J.H. Drummond, a respected businessman who became the first mayor of St. Andrews in 1908. He was instrumental in securing the Gulf Inland Waterway, now called the Intracoastal Waterway, as well as constructing a railway spur from St. Andrews to Panama City. He claimed among his many friends one William Howard Taft.

From the 1930s onward, the building became a real estate office, a secondhand shop and the St. Andrew Bakery. The building gained a second floor in the 1950s, which was occupied by a painter, followed by the Beach Bag Gift Shop in 1975. From 1979 onward, the building was rarely used until 1988, when it became a police substation.

Late in 2005, Coastal Community Bank bought the property and began extensive renovations, much of which can be seen today. Reproduction copper press ceiling tiles complete with wooden fans and dark period wood-framed teller windows mimic the style of the original bank and give an old-world feel to the place. Given the age of this illustrious building, it is perhaps inevitable that it would attract spirits and phantoms.

Jennifer Vigil, CEO of the recently formed Panama City Development Corporation, has her office in this building, along with Shelby and Nicole. All three have encountered some happenings in the building that are difficult

Oaks by the Bay.

Old Bank of St. Andrews.

to explain away. Jennifer has a board with her name on it propped up in an internal window. Occasionally when she is not in the room, it will crash to the floor, even though no doors have been opened or shut to upset it. Shelby thinks this may be a mayhem-loving ghost that has occasionally followed her out of the building around town. On the same day as the board first fell, she visited downtown and entered the Little Mustard Seed antique shop, where a shelf she was not touching fell over and several items broke, causing her to scream in shock. Shelby's next stop was the Downtown Improvement Board offices next door. While she was here, a large pile of neatly stacked clipboards crashed onto the carpet.

Strangest of all is the mysterious music that plays by itself. Occasionally, strange music will fill the air at the office. On hearing the unusual music, one of the three ladies will go to the cupboard where the iPad is kept. The music will cease as they open the door to discover that the iPad is turned off or has a dead battery. They have checked to see if their neighbors have music playing, but this has not been the case.

One evening at about 8:00 p.m., having returned to collect some items from the empty building after a hearty meal at the nearby Shrimp Boat, Shelby heard the music start to play. She did not hang about to find out more but left as fast as she could. The employees have all heard banging at odd times and been unable to identify the source.

A psychic visitor to the building, Julie Gordon, felt immediately that there was a presence nearby. Julie has been reading people and houses since childhood and believes she has "antennae" to see into the past. On entering the old bank, Julie sensed someone upstairs, even though the floor is no longer there. She sees a gentleman in an old Wild West costume with a paisley scarf over his nose and a hat similar to that of a cowboy. He is not a threatening presence but is highly protective of the place or someone in it.

There is also feminine energy of a teenage girl, possibly someone who once worked in the building. The man is keeping a watchful eye on the front door. Julie senses a connection to Jersey Lilly Saloon, an old bar dating to the nineteenth century, that was once located across Highway 98 from Gulf Coast State College although it no longer exists. Gladys also mentions this saloon as a haunted spot, and tales tell of an apparition and a magnum of champagne being thrown across the bar. A man was killed here, and Julie sees it as the same man as the cowboy. He is most likely watching the door of the old bank to stop the girl he is fond of from heading to this saloon to become a prostitute. Julie believes the girl met an untimely death by yellow fever, and the gentleman is locked into that time due to excessive grief.

THE SMOKER OF CALLAWAY

Another distinct area of Panama City is on the east side of town: Callaway, named after Pitt Milner Callaway, a Baptist minister from Eufaula, Alabama. He bought the land from E.G. Langston in 1855 and hoped to build a great seaport. His dream was to turn the area into the "Chicago of the South." He also tried to build a railway from Dothan, but neither dream came to fruition. Eventually, he gave his holdings to his daughter Ella and her husband, Moses Carlisle. Their daughter Lillian married M.B. West, founder of Panama City and publisher of the *Panama City Pilot*.

Callaway Historical Society is a small but thriving association of likeminded people with a love of preserving the past in their area. A wonderful event was held in May 2016 with homesteaders and family members who spoke fondly of their time in Callaway. Johnny Davis spoke of a time when the roads were made of dirt and cattle roamed freely in the woodland unfenced. His grandfather bought land at the turn of the century for about $1.25 per acre. Jeanette Brightwell of the Sorensen family spoke fondly of her grandparents' time here with a forty-acre holding on Cherry Street where they had dairy cattle, including Guernsey cows and Rhode Island Red chickens with the first incubator in the locality, as well as fruit trees. A lady dressed to resemble one-time schoolmistress Ettie Fox spoke of the lumber mills, the turpentine industry and the moonshine stills. She also remembered orchards of peaches, plums and satsumas, along with some vineyards and much vegetable growing.

Fishing was important to the community, and each villager had a handmade net until they decided to join them together to catch more mullet. Nets were known as gill nets and were soaked in oak bark to turn them green to prevent fish from becoming too suspicious. A large catch of mullet would be salted and used to trade with Georgia merchants for flour and sugar. The flour barrels were eventually used for salting the fish. Nothing was wasted in those days.

There is still a strong sense of community in Callaway, and it was great to meet Bertie Shuster (née Fox), who was ninety-eight years and twenty days old at the time of the supper and whose family had started a homestead on Cherry Street in 1886.

The Callaway street of most interest to seekers of the paranormal is Beulah Avenue, now home to a one-room schoolhouse dating back to 1911. It was originally built on a nearby site but sold to the county for one dollar and preserved for all to visit. Grandma Ettie Fox was instrumental in gaining a schoolhouse for Callaway, believing every child should have the opportunity to read. Before its opening, children had to walk some miles through woods and across streams to Parker for their education. It is wonderful to see: furnished with old desks in rows facing the dais, on which sits the teacher's high desk and a piano. All sorts of memorabilia line the walls, from a blackboard complete with chalk and eraser to maps and examples of writing to intrigue the young and bring reminiscences to the not-so-young.

I would struggle to pass the eighth grade final exam in 1895:

> *Give nine rules for the use of Capital Letters.*
> *Define verse, stanza and paragraph*
> *Name and define the Fundamental Rules of Arithmetic.*
> *District No. 33 has a valuation of $35,000. What is the necessary levy to carry on a school seven months at $50 per month, and have $104 for incidentals?*

Could you manage such questions and more in the five-hour test?

The school was in operation until 1936, attended by the families living and working in Callaway in the turpentine, lumber and fishing industries. Callaway now has its own elementary school.

But despite the one-room schoolhouse's age and history, Beulah Avenue's ghost haunts another building: a residential house once inhabited by a notorious chain smoker. This gentleman died some years ago, but the present occupants think he may not have fully left. Upon taking possession of the house,

Old Callaway School.

they frequently heard unexplainable noises, usually coming from the garage. They allowed a local paranormal group to investigate the house, and according to Tony Simmons in the *News Herald*, when the electronic ghost hunting equipment was in place, they heard interesting words on their Ghost Radar app such as "tobacco," "yellow" and "teeth," comments quite likely to be made by a chain smoker. Another word that appeared on the screen was "garage," which was, interestingly, the area from where the strange noises emanated.

Parker Branch on the western edge of Callaway Bayou, once home to Indians, is believed to be a haunted area. Both an Indian boy wearing a loincloth and a Civil War soldier have been seen in a home on Comet Avenue, according to Marlene Womack in the *News Herald*.

Allanton—formerly Baxter, in both instances named for the postmaster— is another area of Callaway. Years ago, youngsters believed in a haunted house at the end of a loop on the bayou. It was in fact the Allan House of two or three stories, surrounded by magnolias and live oaks. It was built like a fortress and was very imposing. Perhaps members of the Allan family hung around after passing to keep an eye on their property. The house is no longer there, and neither is the nearby ferry that used to take people from Allanton across the bayou to the towns of Farmdale, Redfish Point and Cromaton— now ghost towns since Tyndall Air Force Base took over the land.

TYNDALL AIR FORCE BASE

Tyndall Air Force Base, located twelve miles east of Panama City, is named after World War I pilot First Lieutenant Frank Benjamin Tyndall. Born in 1894 in Sewell's Point, Florida, Tyndall joined the air force in 1916 at age twenty-two. He was an ace fighter pilot with the Twenty-Second Aero Squadron, achieving a silver star for gallantry in action, surviving four if not six aerial victories. He chased an enemy Fokker far across enemy lines and managed to bring it down. He was also the second man to survive by use of a parachute.

Sadly, he was killed on July 15, 1930, while flying from Virginia to Texas for an assessment to study battle tactics. He flew into a dense fog, and unable to find a landing field, he crashed down in North Carolina. He is buried at Arlington Cemetery in Virginia. Ten years after his death, the military purchased the land for the Tyndall Air Force Base and named it in honor of Lieutenant Tyndall.

Before the base opened in 1941, Tyndall was home to three small villages—Cromaton, San Blas and Farmdale—each with a few houses and a post office.

A Methodist minister from Baltimore, Reverend W.M. Croman, visited the area in the 1880s and loved it so much that he decided to stay. Seeing the potential for tourists, he built a three-story hotel and worked to develop Cromaton, the little town that bore his name. It looked as if nothing could stop this town from flourishing. However, the government purchase of the land changed everything. The town's buildings were torn down or fell down,

leaving only the cemetery with forty-five graves as a reminder of this once thriving community.

Small wonder that this area is thought to be haunted. People have spotted what they thought was the light from flashlights, until further inspection revealed them to be orbs. Unexplained lights have been seen in the woods and swamps of Tyndall on a fairly regular basis in the past, but now the airport lights make them harder to see. According to Marlene Womack in *Ghost Towns, Mysteries, and Tombstone Tales*, the lights may be will-o'-the-wisps, as some people have observed lights growing larger and brighter and taking on the form of a person if approached. A good way to

Lieutenant Frank Benjamin Tyndall. *Courtesy local government.*

try to capture an orb on film is to set the camera to take a few photographs in rapid succession and compare them later. Notice first if there are any lights in the area you might expect to show up on film so that these may be eliminated.

Womack also tells of the "Thompson Place" on ground that is now Tyndall Hospital. There were strange noises heard in the house and banging doors supposedly latched, knocking on the walls and, on one occasion, the sound of wild hogs grunting in the kitchen, yet on opening the door, no animals were inside.

In her latest book, Womack tells a tale of a Cromaton faith healer allegedly seen after his death by some teenagers. It involves a little old man in a rocking chair who disappeared, only to reappear in a coffin previously noted as empty.

THE BERRY PICKER

One tradition I miss from my childhood in England is picking blackberries from the hedgerows in the autumn. Handpicked berries, after a walk in the fall sunshine, tasted so much better than bought ones.

No doubt the old woman from Freshwater Bayou in the late 1800s enjoyed gathering and eating blackberries, or their relative dewberries, which she gathered in the spring. This old woman features in a tragic tale. Her beloved husband had descended into madness, and he was to be transported to the insane asylum in Chattahoochee. Neighbors tied him to the transport wagon to restrain him during the ride, and his screams could be heard throughout the forest. Fearing he might not arrive safely, his wife followed behind the wagon through the entire journey. This would have been a long journey of some sixty miles northeast of Panama City at the confluence of the Flint and Chattahoochee Rivers. It is not documented how she reacted upon arriving at the asylum, as rumors of the care in this facility, as of many others in the nineteenth century, are not good.

On returning home, the old lady continued to pick berries. Others used to sail across from Panama City to Freshwater Bayou to gather fruit too. Over the years, this practice waned as people began to experience a strange phenomenon. While out in the fields, people began to report seeing a woman gathering berries who, according to Marlene Womack in the *News Herald* in 1993, would fade as people approached—first her lower half and then her top half until she would vanish altogether.

Lady picking oranges. *Courtesy Bay County Library.*

Originally a federal arsenal during the Second Seminole and Civil Wars, the Florida State Hospital, called by most locals simply Chattahoochee, became a penitentiary in 1868. The first recorded inmate, Calvin Williams, was sentenced to a year for larceny. The warden, Malachi Martin, was infamous for his cruelty and corruption, the latter enabling him to accrue a large fortune. In 1876, the building became the Florida Asylum for the Indigent Insane.

Inmates of note include Kenneth Donaldson, who wrote *Insanity Inside Out*. He took his case of wrongful incarceration to the Supreme Court. This brought about necessary changes in commitment procedures in Florida and nationwide. Emmett Foley took his story of squalid conditions and abuse to Hollywood in the film *Chattahoochee*.

Stories of patient abuse were common, including bodily harm and neglect, as well as harsh therapies such as ECT and lobotomies. Worst of all, perhaps, was the fact that many of the incarcerated men, women and children were completely sane but had become nuisances to their families or people of power, who saw the asylum as a useful way to be rid of them. Reasons for a person to be incarcerated included sunbathing nude, homosexuality and menopausal symptoms. Some of the patients were criminals who had pleaded insanity or were judged to be insane by the courts. The plan was to treat them and then return them to prison to complete their sentences.

PART II

LYNN HAVEN

AUNT MINNIE'S CLOSET

Lynn Haven, founded in 1911 as a home for Union veterans, was so chosen along with two other sites—Fitzgerald, Georgia, and St. Cloud, Florida—for the "health, climate and productiveness of the soil." The veterans were given five-acre plots on which to grow food. They set about building houses and gave them northern-style roofs, as they were used to more rain and snow. The only Civil War monument in the South dedicated to Union soldiers is the one at the corner of Georgia Avenue and Eighth Street in Lynn Haven.

The developers of this area were W.H. Lynn, A.J. Gay and R.L. McKenzie. The town took its name from William Lynn. Growth was rapid, from 200 people in June 1911 to 1,200 by December of the same year. Although part of Panama City North, Lynn Haven maintains its own special identity, as well as its own haunted city hall. City officials approved Henry T. Hey's plans for the new city hall in 1927. The Spanish-style building was completed in 1928 by Jacobs and Harrington. Housed here were the tax collector's office, a council chamber, a vault for city records, three jail cells and the fire department. At the same time, a new city charter was approved.

Charlene Messer has worked in city hall for over thirty years and was kind enough to show me around. First, she took me to a small office where a billing lady had a chilling experience. With her back to the door as she stood by the printer, someone swept their hand across her lower back. She felt so scared that she immediately shut the printer down and left the room.

Statue of Union soldier.

During my tour, I met David Messer, a policeman in the area for over forty years. He told me of two hangings in the 1960s in the building, presumed suicides, although there is a suggestion of foul play, along with the disappearance of photographic evidence. Since the death of these two young men, many people have heard footsteps on the stairs even though they have been alone in the building. David was working at 2:00 a.m. one morning when he heard someone go up the stairs next to his office. Hearing the steps descending, he went out to see who was there but saw no one. At least five other policemen heard the footsteps on different occasions and would no longer work there at night by themselves. They discussed the possibility of rats in the building, but all declared the sound they heard to be the footsteps of a man.

Auditor Richard McKenny was working in city hall until 8:30 p.m. one night. As he was leaving by way of the stairs, the light came on before he reached the switch. Halfway down the said stairs, the light went off and then on again. He was in the middle of the stairs, nowhere near the switch at the top or the bottom, and no one else was playing a trick on him. He was keen to leave the building.

Recently, Amanda Jayne Richard was in the building as evening fell and heard the highly identifiable sound of keys jangling. Heading to the rear of the room and location of the prison cells in years gone by, there was no one to be seen. Amanda is less keen to be alone in the building again.

A fascinating room at the top of city hall is known as Aunt Minnie's closet. Located just below the bell tower, it features a pretty arched window. From this room, it is possible to get to the bell tower to check on the hourly chiming clock. No one remembers how the room got its name. Minnie was a popular girl's name in the 1880s, being the fifth or sixth most used. It began its decline in the 1930s and by 1975 was out of fashion, perhaps because of the association with Minnie Mouse.

Developer William Lynn had a daughter, Mary, and Minnie Milton was a student at Bay High School in 1917. However, I can find no obvious reason for the name of this quaint room, not even a generic interpretation for a small cubby hole.

COLLEGE POINT

Rumors of hauntings and demonic figures swirl around the rubble of Bob Jones College in Lynn Haven. Now called Bob Jones University and located in South Carolina, the original college was founded in Bay County in the early twentieth century.

Dr. Bob Jones, a Methodist minister, built the 470-acre campus in 1927. He envisioned "a thoroughly Christian college that stood on the absolute authority of the Bible to train America's youth," according to the Bob Jones University website. Much money was raised locally for this endeavor. The chapel dormitories and other buildings were beautifully located on the bay, previously known as Long Point. Rules were strict, but pupils appeared to flourish in this environment. Eighty-eight students were enrolled in 1927 at a cost of $25 a month for room and board. Nine months' tuition was $125.

According to the memorial stone in Lynn Haven, the college was referred to as the "World's Most Unusual University." The description was apt in various ways. For one, it was a coeducational institute, which Florida was notoriously slow to normalize. Students received demerits for talking with the opposite sex, but of course, some students thought it was worth the risk and stopped just short of collecting the number of demerits that would have sent them home. Girls could get demerits if their skirts were less than two inches below their knees. Being late for meals or classes also resulted in a demerit.

The emphasis on a healthy body as well as a healthy mind was also unusual for the times. Notice the track at the far side of the picture. Chapel

Left: Dr. Bob Jones. *Courtesy Bay County Library.*

Below: College Point campus. *Courtesy Bay County Library.*

was of supreme importance, and attendance was required daily, with biblical studies a large part of the curriculum.

A lesson for August 7, 1932, begins as follows:

THE TEN COMMANDMENTS—DUTIES TO GOD
Lesson Text—Exodus 20:1–11
Golden Text—Thou shalt love the lord thy God with all thine heart, with all thy soul and with all thy strength.—Deuteronomy 6:5
Primary Topic—The giving of the Ten Commandments
Junior Topic—The Giving of the Ten Commandments
Intermediate and Senior Topic—Loving and Worshipping God.
Young People and Adult Topic—Giving God First Place.
The Ten Commandments furnish us with the greatest moral code the world has ever seen. The law was not given to save sinners, nor to rule saints, but to reveal sin (Rom. 3:19, 20) and to lead to Christ (Gal. 3:24).

Nothing but rubble remains of the college today. Legend tells of a maniacal teacher burning down the school. Pupils who died in the fire were left to wander the grounds as ghosts, screaming in eternal agony. Another rumor tells of a farmer gone mad. Brandishing a sawn-off double-barrel shotgun, in his rage he rushed into a dormitory. Incensed by noisy students, he went on a rampage, shooting at least twenty of them. The crazed farmer then put the gun in his own mouth and pulled the trigger. Ghosts of the students are said to still roam the grounds, looking for a way to rest in peace.

Although fascinating, both are decidedly false stories; the college closed its doors in 1933 because of financial difficulties, due in part to the Depression. Nevertheless, rumors of ghosts persist around the old college.

During the 1980s, the ruins on the college grounds were an excellent setting for ghost stories to grow and prosper. This place was a popular hangout for teens to look for adventure and experiment with alcohol and other such illegal substances. Considering the nighttime activities, the location remained remarkably trash free. The spooky suggestion was that ghosts picked up the litter for them!

In the February 7, 2013 issue of the *News Herald*, Brady Calhoun talks of demonic activity where phantoms would allegedly appear looking featureless and genderless, "like a flat black mannequin," according to his source.

Matt Anderson reported to Calhoun that he "once watched his friend, whom he described as, 'James the Satanist,' get beaten up by an invisible

presence. When it was there, you could feel it. 'It was just oppressive,' Anderson said."

Then the presence started to follow James home. His father would not believe the story but sent his son to a priest anyway.

The priest believed him and said, "Something followed you here. I can feel it. It's outside but it won't follow you into the rectory."

How this story ended is uncertain, but presumably the priest was able to help the boy.

The wooded area near the old college is reputedly haunted by a girl dressed in white. Locals claim they have seen her in the old Lovers' Lane. The story suggests that a college student met his lover here. The girl died tragically, and on hearing the news, the heartbroken young man returned to his dormitory, where he hanged himself. The girl still waits in the lane for her lover to return. Although a romantic story, again there is no record of such an occurrence.

Sadly, a pile of rubble is almost all that remains of the college, as the land is now a residential neighborhood. The college itself moved to Cleveland, Tennessee, in 1933 and then to Greenville, South Carolina, in 1947. If you visit College Point, you may see the old university gateposts and the memorial erected in 1976.

CIVIL WAR VETERAN

Located in Lynn Haven, the Ackerson House dates from 1911. It was built by and for Civil War veteran John Ackerson and his wife, Henriette, or Retta. John died in the house in 1920; his name is listed on the Lynn Haven Memorial Civil War monument honoring Union soldiers.

Lynn Haven was settled by Union soldiers from the North in the early twentieth century as the third of three Union veteran colonies established in the South. The graveyard, dating from 1912, is a good source of genealogy for those looking for Civil War ancestors. John Ackerson was a sergeant in Company A, 160th New York Infantry. Years before Lynn Haven was settled by veterans from northern states, Native American Indians dwelled at this location. Many artifacts have been found in the region of the Panama Country Club, including a burial site nearby full of pots and other relics uncovered by archaeologists. Most of the collection can be viewed at the National Museum of the American Indian in Washington, D.C.

I have heard rumors that an American Indian woman in full regalia with a feathered headdress has appeared in a Lynn Haven kitchen; unfortunately, I have been unable to substantiate this story, but I am keeping my ears open and my eyes peeled.

Belinda Betz moved into the Ackerson House on West Fourth Street in 1989. During the early years living there with her family, they heard voices conversing in one of the bedrooms on at least six different occasions. The talking stopped if they opened the door. Their son who occupied the

John and Mary Rowley Home.

bedroom, Jason, would be sound asleep, but the voices were from more than one person. The intonations suggested two people having a discussion. The room had been the master bedroom for previous owners.

A further strange occurrence in the Ackerson House related to a pair of chairs. Bought at an estate sale and brought into the house, these Jacobean chairs had previously stood in the corner of an old dining room. No one was allowed to sit on them except for a teddy bear that was there to stop others from occupying these stately seats. Nobody had sat on them for twenty years. It was common to have a lady's chair and a gentleman's chair in the nineteenth century. The gentleman's chair had arms, but the lady's chair did not, as her skirts would have been too wide to accommodate.

One night, while a friend slept in the room in which the chairs now sat, the young lady awoke in the early hours of the morning to find a man sitting on the larger of the two chairs. She was terrified and left the room. The next day, she removed the seats to a large closet. The gentleman's chair has since been sold. I am now the proud possessor of the lady's chair and am awaiting any visitors with bated breath!

A third strange happening for this haunted house is connected to the extraterrestrial sphere. Belinda's daughter, who was three at the time, sought

out her mother, who was multitasking by folding laundry and watching an early episode of *Phil Donahue.*

Savannah, the little girl, said, "Mum, I have a friend who visits me at night. He never comes into the room; he stands outside in the hall. I'm not afraid of him."

At the last comment, Belinda began to take notice and asked if she knew the person's name or where he was from. Savannah didn't know the name but was adamant that he was from outer space. Alien or ghost, I wonder?

THE OLD LYNN HAVEN
GRAMMAR SCHOOL

Close to the 390 by Colorado Avenue stands this historic African American school, built in 1927 to replace March Green Grammar School on nearby Illinois Avenue and Fifteenth Street. The Lynn Haven School ceased to exist for education in 1950.

Although the front porch is new, the original façade with two entrances—one for boys, the other for girls—is still in evidence once one enters through the first door. A wood-burning stove used to sit on the back wall to heat the building in the winter months, when it can be surprisingly cold in northwest Florida. Former pupil Robert Cain remembers getting wood for this heater, as well as surviving with an outdoor bathroom and no electricity. He says a common classroom punishment was to be told "to go into the cloakroom and close the door." The classrooms are spacious, with high ceilings, and originally had tongue-and-groove wooden slats on the walls.

Former Lynn Haven mayor Sharon Sheffield attended this school in 1947. A.D. Harris was the principal and his wife a teacher. Sheffield told the *Lynn Haven Ledger* on September 16, 2010, that there was a family feeling to the school, and she liked to learn and get good grades. However, she hated the school nurse, who she described as "mean," and would run home if an inspection was due. Sheffield was always taken right back.

Jim Crow laws existed in Florida for many years. In 1885, the law proclaimed that "white and colored children shall not be taught in the same school." In 1913, another law stated, "It is unlawful for white teachers to

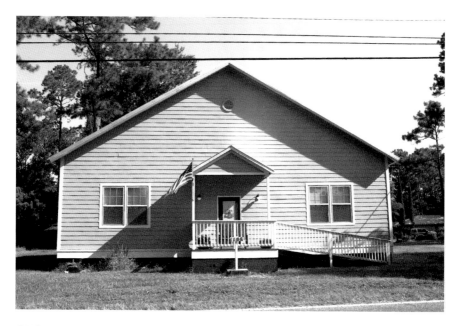

Old Lynn Haven Grammar School.

teach Negroes in Negro schools and for Negro teachers to teach in white schools." Penalties could be as much as $500 or imprisonment for six months.

Schools were not the only places of segregation at that time. People of color were not allowed to swim or bathe in the sea or bays where white people were used to bathing. They were not able to use the same transport or live in the same residential areas. As reported in the *Panama City Pilot* of June 21, 1935, St. Andrews State Park had a separate pier built for use by colored people. There was also a whites-only bathhouse at the park as late as the 1950s.

More recently, the old school was used by the Disabled American Veterans (DAV), who held meetings here. It is currently owned and renovated by longtime resident David Byrd. On the first occasion he entered the property, Byrd took plenty of photographs. Later, he was amazed to see two or three orbs in his photos. The one on the floor by the sign seems to have all the features of a face inside. Perhaps the school nurse has never really left and is still carrying out inspections!

Orbs, sometimes referred to as "ghost orbs" or "spirit orbs," are believed by many to be visible manifestations of the souls of the departed. However, they may be a trick of the light, flash back from the camera, dust, pollen, moisture or a reflection. Each person has to make up their own mind. But

Above: The pier at St. Andrews State Park.

Left: Orbs in the old grammar school. *Courtesy David Byrd.*

in this particular case, enlarging the orb by the DAV sign reveals two eyes, a nose and a mouth quite distinctly.

Byrd is no stranger to ghostly phenomena, having spent much of his childhood growing up in an old house on Tennessee Avenue. Built in 1912, this house has been lived in, altered and rented out many times over the last century. Strangely, no one seems to have stayed in it for very long. Unrelated tenants all have similar eerie stories, such as hearing footsteps on the stairs when nobody else is home. Lights mysteriously turn themselves on and off. One family remembers an occasion when they left the house, leaving all the windows open to let in fresh air. When a storm began to brew, the family

A house on Tennessee Avenue.

rushed home to close them, only to find the windows completely shut on their return.

Renters have reported strange feelings along with sightings of a woman. Once, as two tenants were arguing, an orb floated through the wall behind a girl with a ponytail and flipped her hair up before disappearing through the opposite wall. The couple moved out soon afterward. On another occasion, a young man had just dropped his date off at the house, then her home, when he spotted a woman sitting in a wicker chair on the porch. The boyfriend assumed it was his date's mother waiting for her to arrive home. He watched the woman follow his girlfriend into the house before driving away. How surprised he was the next time they met to discover that her mother had been fast asleep in bed when she had arrived home.

A little boy of three or four wandered upstairs when his mother was visiting. Returning to the living room, he announced that the people upstairs had told him it was their home, although there was no one upstairs at the time. One tenant saw a man smoking a cigarette walk through the yard and on into the pine trees. He never reappeared.

Much discomfort has been felt in the downstairs bedroom. Gladys of Capstone House, who has had a life full of many ghostly happenings, spent some time in this room one September evening, and she picked up on a great

sadness, possibly abuse, emanating from a corner of the room. She had a glimpse of a small lady with short brown hair who was very unhappy and had lived there a long time ago. This was the room that housed a mirror on which handprints appeared that didn't match anyone's in the house. Once, a name beginning with a J, possibly Jane, was discernable in the dust of this looking glass.

PART III

THE BEACH

CAMP HELEN

In 1928, the land that is now Camp Helen State Park on the outskirts of Bay County was owned by the Hicks family. Robert E. Hicks bought 185 acres for his wife, Margaret. She named the place Loch Lomond, presumably because she was reminded of Scotland and nostalgic for the home of her ancestors. Water lies on three sides of the campground: the Gulf of Mexico, Philips Inlet and Lake Powell. Their house, called the Lodge, was very grand, made of cedar with five fireplaces, four bedrooms and a beautiful view of the lake. On her husband's death, Margaret worked hard to keep the place as a going concern. This was difficult in the 1930s as the Great Depression devastated the country. Margaret decided to add a few buildings and take in paying guests to support herself and her children. The Rainbow Cottages she added had sleeping space for two to four people, a kitchen and bathroom.

Margaret must have been ready to leave Loch Lomond after the death of her only grandson, four-year-old "Gigi" (probably Gerald). Margaret had left blond, blue-eyed Gigi in the care of the cook and a nursemaid while she went grocery shopping in nearby Panama City. While they were preparing his lunch, he went into the courtyard to play. They called for him when lunch was ready but got no reply. Gigi had wandered off to the boat dock on Lake Powell and fallen in and drowned.

It was 1996 when his ghost was first noticed by a fisherman. While out on the lake, he saw a small boy playing on the sand. When he made inquiries, he was surprised to learn from the caretaker that no one lived on the property.

Rainbow Cottages.

A dock at Camp Helen.

Other people have seen him since, usually fishermen who spot a little boy on the dock. Although Gigi is often spotted playing by himself, he reportedly isn't alone in haunting the park.

Donald Cromer of Avondale Mills, Sylacauga, bought the property from Margaret in 1945. At about the time of the sale, a guest of the Hicks family is reported to have spoken to a ghost while staying in the lodge. Imagine a rather stern Sunday school teacher from Birmingham, Alabama, admitting to seeing a ghost! According to local historian Emily Smith, "He had dinner, went to bed early and slept in Margaret Hicks's old room, and when he went to sleep during the night, this ghost appeared beside him."

"This is my house; get out of my house!" the ghost demanded.

It is believed to be the ghost of Captain Philips, for whom the inlet is named. In 1840, Captain Philips and his crew were stranded here in shallow waters; they were attacked and killed by Indians.

For over four thousand years, this area was home to Indian tribes, drawn here by the abundant seafood, namely mussels, which encouraged the growth of cedars and hickory trees. Prehistoric middens and mounds are still in evidence on the land.

The Indians were not very friendly to new settlers in these parts, as evidenced by another ghostly tale. Rose, a slave girl, was massacred by Indians in 1843. There was a huge storm on the Gulf of Mexico on New Year's Eve. How frightened Rose must have been to be aboard ship in such weather. The ship was heading to Apalachicola but ran aground on the beach. Captain Newnon was overseeing repairs and watching the crew secure the ship as Rose set up camp.

Rose may have been looking for food or firewood when she came upon a band of Creek Indians. Hearing a scream, the captain turned and saw Rose running down the beach, pursued by Indians. They caught and killed her, ripping off a gold earring in the process. She was buried in a shallow grave, and it is believed that she walks alone along the beach on moonlit nights. Some even claim to hear her screaming or calling for the captain to help her. Legend suggests that she is searching for her missing earring.

Avondale Mills used the park as a holiday camp for its employees to have leisure time and renamed it Camp Helen after a family member. It was sold as a park for all to enjoy in 1966.

Hurricane Eloise blew through in 1975, and the boathouse and dock were lost. Other buildings remain, and the park is worth a visit for the flora and fauna, as well as the history. There used to be yearly ghost walks from 2006 until 2013.

Billy Bowlegs and the Headless Ghost

While *Pirates of the Caribbean* thrills moviegoers, the local story of Pirate Billy Bowlegs haunts the shores of North Florida. Santa Rosa Island was a great base for a pirate, with the Gulf of Mexico on one side and the quiet waters of Santa Rosa Sound on the other, with plenty of vegetation to hide out among.

Billy Bowlegs did not really have legs suggestive of years spent in the saddle. The name Bowlegs was a fairly common name, originally Bolek or Bowleck. The best-known Bowleg was a descendant of Halpatter-Micco, a direct descendant of Secoffee, founder of the Seminoles.

Billy left Mississippi for Florida in 1810 with a herd of cattle. The cattle were a useful cover for other activities. Whenever he wanted to go pirating, he would claim he was tending to his cattle. Billy would set off from Santa Rosa in search of adventure in and around the numerous inlets and bays off the North Florida coast. He would go for weeks on end, leaving his young wife alone and prey to the advances of a dashing Spanish officer.

On returning to Santa Rosa and hearing of her infidelity, Billy was enraged; he is supposed to have killed the young officer before turning on his wife and chopping off her head. Rumor has it that at midnight on moonlit nights, the spirit of his young wife roams the dunes looking for her lost love, perhaps in the area now called Lady's Walk.

Other accounts suggest that the headless woman is that of a young girl murdered in the early 1800s. She was on board a four-masted schooner sailing to Pensacola when she overheard pirates discussing where to bury

their treasure and therefore had to be silenced. She is seen carrying her head in her arms by fishermen casting their nets along the coast.

Another theory is that the poor soul belongs to Theodosia Burr Alston, who left Charleston on December 30, 1812, aboard the *Patriot*, heading for New York to see her father. She was never heard of again. The ship may have sunk, or she may have been forced to walk the plank; perhaps she was held hostage before having her head cut off. No one knows, nor do I know why her husband, Joseph Alston, governor of South Carolina, would look for her and his treasure that was on board with his charming twenty-nine-year-old wife in Pensacola. That would be a circuitous route from Charleston to New York!

Billy's last voyage was also his trickiest. Billy had raided so much gold from Yucatan that his crew had to throw the cannons overboard to make room for more gold. With no means of defense, he was chased and shot at by a British man-of-war. He made it home by taking his battered ship over a shallow sandbar into the bay. The deep hull of the British ship prevented it following; however, they continued the chase with a couple of longboats. Billy's crew sank the ship and sawed off the masts, leaving the boat hidden before swimming ashore. A threatening storm caused the British to turn away without capturing their quarry.

Uncle Saul Rogers, a possible descendant of Billy Bowlegs himself, has a ghostly tale to tell, according to Ethel Calhoun in the *Panama City News Herald*. Saul and his friends were sailing in Santa Rosa Sound and pulled ashore to make a fire and enjoy some coffee. They heard a shrill whistling sound ripping through the ship's rigging. They ignored it, thinking it was a gust of wind. But they were certainly spooked when their coffeepot jumped out of the fire as if kicked by an invisible foot!

Billy was buried in 1864 on the mainland near Mary Ester close to Santa Rosa Island. Treasure hunters have searched for his grave by day and night in the hope of finding more gold. On his deathbed in a Florida cabin, Billy had reportedly told his friend Moses Hudson, "They may find some of my treasure, but they'll never find all of it!"

His grave is to be found with branches nearby that rub together in the wind, causing eerie sounds on windy nights. Locals say it is Billy crying over lost treasure. Others claim that his ghost hovers beside his grave-side live oaks at midnight—keeping an eye on his gold perhaps.

RIPLEY'S BELIEVE IT OR NOT!

Visitors to Panama City Beach can't miss the huge ship on Front Beach Road. When the weather is too rainy or too hot to spend the day outdoors, Ripley's Believe It or Not! is well worth a visit, as it is full of entertainment for young and old alike. The nimble will enjoy LaseRace by pretending to be jewel thieves climbing over and under lasers in a James Bond–style scenario. The hall of mirrors will frustrate and amuse those with even the best sense of direction.

However, of greatest interest to many are the curios, from a pirate's blunderbuss to shrunken heads; from tales of the *Titanic* to a bust of Thomas Wedders with the longest nose in history (it was seven and a half inches long!). There are artifacts and photographs that Robert Leroy Ripley gathered from all over the world: huge model ships carved in ivory or jade; swords; skulls and fertility symbols from Africa; and a traveler's vampire extermination kit from Romania, complete with garlic, holy water and a stake. It is not beyond the realm of the imagination to expect that negative energies may be connected to some of these gruesome weapons and cannibal skulls. I noticed a particularly gruesome African executioner's sword, as well as a Fuji Ished cannibal fork.

Not surprisingly, paranormal investigator Sean Austin recorded frequencies of dark magic in the room with the Ecuadorian shrunken heads. Members of the Jivaroan tribe from the northern Amazon rain forest would decapitate their victims, followed by cooking and thereby shrinking the heads. There was an art to this; too much boiling and the head would lose hair,

too little and it would not be hardened enough. This process reduced the size by a third, but more work was needed. Hot stones and sand would be added to the inside of the skull to help it shrink from within, as well as preserve it. Finally, the small head would be hung over a fire to harden and blacken. Charcoal and ash were also rubbed into the skin to darken and seal it, thereby preventing the souls from seeping out and seeking revenge. The head was considered a trophy and sign of victory but was discarded after celebrations were over. In the picture, it can be seen that the eyelids have been sewn together and the mouth skewered closed with wooden pegs. This happened before the boiling took place.

A shrunken head.

Audra Ely, Ripley's manager, had interesting tales to tell and is convinced the ship is haunted, either from people who lived on the land before it was Ripley's Believe It or Not! or from the artifacts inside. Whenever she is in the African room after closing, she feels as if someone is watching her, and she has heard odd noises. Strange but true is the handprint she kept finding inside the case of the African shaman exorcist who is decorated in a vest of human bone. However many times the case was cleaned inside and out, the handprint would always reappear in the same place inside by morning. None of the staff was very keen to look after this display case. The light was continually blowing out in this case too. Eventually, the exorcist was moved farther back in the display cabinet to accommodate three Chinese temple statues whose fingers were being broken by inquisitive fingers touching them on the outside. Nothing has happened since. The shaman seems quieter in this new position—or perhaps he can no longer reach the glass!

Audra is no newcomer to strange phenomena, as during her time in Missouri, she was followed home from a renovation site by a small girl who claimed she was looking for her mom. Eventually, Audra had to tell the ghost girl to leave her house, as even Audra's mother was able to hear her playing in the background when they were on the phone together…spooky.

Previous supervisors at Panama City Beach's Ripley's have felt a tingling in their spine or goose flesh on their arms from time to time, but Audra is picking up on even more. Once, she saw a man walk past the top of a flight of stairs. This was after closing time, as Audra was turning out the lights. On another occasion, as she turned the three TV panels off, a man in a suit appeared mysteriously in the middle screen. Audra senses that the spirits are accepting of her, as she happily talks to mannequins on display. They are not so fond of other people who have tried to communicate; Audra's husband, Brendan, felt quite uncomfortable on the evening of an investigation after hours. He was skeptical about paranormal activity; he thought it was strange that after some remodeling there would be knocking on the office door, as this door no longer led anywhere, just into a closet. However, during the investigation, he felt uncomfortable; he was aware of noises behind and to the side of him and recalls feeling goose bumps on his arms and neck. Worst was in the hall of mirrors, where his hands hurt and circles developed on his palms and fingers. Sensibly, he was encouraged to leave the building, and the redness faded and disappeared. Although he was unwell the following day, he has been fine since. This goes to show that investigations are not undertaken lightly, and protocol needs to be followed if need be, as it was in this instance.

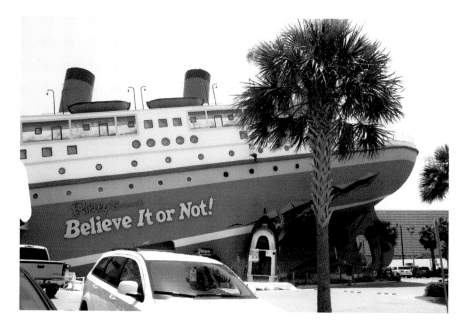

The Ripley Museum.

Investigation by Austin threw up the name "April." Is this someone who worked here when the land was occupied by a bookstore or something else? The month of April is, of course, significant to those connected to the *Titanic*, as it was on April 14, 1912, that the ship collided with an iceberg and by April 15 sank to its watery grave with well over 1,500 passengers and crew members.

PART IV

FARTHER AFIELD

APALACHICOLA

Less than two hours to the east of Panama City and well worth the drive is the quaint town of Apalachicola, named after the Apalachee Indians who inhabited the land along the banks of the river for over ten thousand years. Amazingly, in 1831, this small town was the third-largest cotton port on the Gulf coast after New Orleans and Mobile. By the 1850s, the waterfront was lined with brick warehouses and wide streets to manage the loading and unloading of cotton from nearby plantations in Alabama and Georgia. Steamboats would transport the cotton down the Apalachicola River, where dockworkers unloaded bales of cotton and reloaded them onto small shallow-draft schooners that transported them to the cargo ships moored offshore.

The rerouting of the railroads in the 1850s and the Confederacy blockade of the harbor led to the port's decline. The economy picked up slightly with the 1880s timber boom and increased further in the 1930s with natural sponges and seafood. Oysters from Apalachicola are much sought after in the Panhandle and elsewhere for their pure, mellow, briny flavor.

Every year, the town holds a Chestnut Street Cemetery Walking Tour. Townsfolk dress up in authentic costumes to portray people from the past who were influential in Apalachicola's history. They stand by the appropriate gravestone and tell their story.

Eating a slice of homemade pecan pie in Delores Sweet Shoppe, I discovered a ghost story from the owner and organizer of the cemetery tour, Delores Roux. One day, as she was conducting a tour at Chestnut Street

Apalachicola boats.

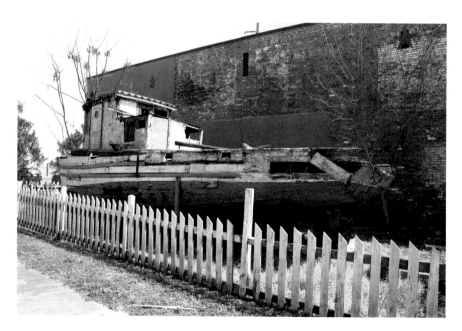

An old Apalachicola boat.

Cemetery, she saw a man wearing a hat, a vest and a watch with fob and chain. She moved toward him to ask him to join the tour, but he disappeared. This apparition has now been seen by Delores three times.

Two people of note from Apalachicola are buried here, including John Gorrie, who invented the ice machine in 1851. This clever innovation was the forerunner for air conditioning. His museum can be found at 46 Sixth Street. Also interred here is Alvin W. Chapman, a botanist of international reputation.

Graves date as far back as 1831. Some tell of important families, such as the Porter brothers, Richard and William, who moved here in 1833 to enter the cotton trade. They prospered and became prominent figures in the town. Other tombs remember Confederate soldiers, while some tell the story of those who died by drowning. These graves have a sad story to tell. Eight-year-old Louisa, while playing on the dock by the river, fell into the water. Her uncle Frank, only one year older, jumped in to save her. She struggled wildly with the added strength that distressed swimmers manage to find, causing him to drown, too, with Louisa's arms wrapped around his neck. Another member of the Messina family, Clarence Joseph, drowned in 1901. A search party looked everywhere for the boy when he failed to return home. His cap and body were found floating in the Apalachicola River; presumably, he fell off the dock and drowned.

Another killer of both young and old alike was yellow fever. The 1841 outbreak was particularly severe. Within days of Samuel S. Sibley, a former Floridian editor, moving from Tallahassee to nearby Port St. Joe, his wife died from the "black vomit," leaving behind her husband and two small children.

Symptoms included fever, chills, headache, backache, weakness and nausea. Some recovered after this, while others moved into phase two, which was often lethal. Increased fever and liver damage came next, causing yellow skin and eyes—hence the name—swiftly followed by the vomiting of a black substance similar to coffee grounds. Then blood would spew from the mouth, eyes and nose, and the patient would fall into a coma and die.

It was assumed that vapors from the marsh rose up and poisoned people. Nowadays, we are aware that mosquito bites cause the disease. Early treatments including morphine, opium, quinine, sodium bicarbonate and castor oil may have been of some help. Bleeding and mercury-based laxatives were probably less helpful and would have weakened a sick patient further. The population of Apalachicola dropped considerably in 1841.

The Franklin County Courthouse is found at 33 Market Street. It was built in 1940 and enlarged in 1969 and again in 1981. By 1930, the original

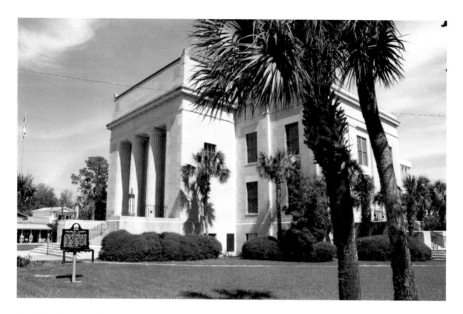

Franklin County Courthouse.

courthouse on Washington Square was too small, so construction began on the new site in 1938, built in Neoclassical Revival style. Two Doric columns dominate the front entrance.

Delores was kind enough to tell me another strange tale as I sipped at my coffee in her café at number 133 Highway 98. She mentioned two ladies, both called Doris, who worked in a basement room in the courthouse. One night, they had locked the doors, as they were inside working late with no one else in the building, when they heard children laughing and running about in the hallway. Of course they looked into the passageway, but nobody was there. One explanation that occurred to me when Delores mentioned playing there as a child in the 1940s was a distortion of time. Delores spoke of roller skating here with friends and actually entering the hallway by a side door to skate. Maybe the two Dorises were hearing noises from another time. An alternate reality is one way to describe this phenomenon. It is not exactly a ghostly experience, as all the children involved are still very much alive, but older. Perhaps the fun and laughter was recorded in the courthouse walls and chose that evening to relive a memory in this way on this day.

At least three of the large houses in Apalachicola have the reputation of being haunted and merit chapters of their own: the Gibson Inn, the Coomb House and the Orman House. These exciting stories can be found in *Haunted Big Bend* by Alan Brown.

PORT ST. JOE

An hour from Panama City on the road east to Apalachicola lies the small town of Port St. Joe, a thriving port in the early nineteenth century when the cotton trade was booming. In 1839, it boasted twelve thousand people and was comparable with Charleston or New Orleans. Shipments of cotton to New England and Europe exceeded fifty thousand bales.

Sadly, in the summer of 1841, a ship from Cuba sailed into port carrying a passenger infected with yellow fever. It spread through the community like wildfire, and within a month, St. Joseph, as it was then called, was a ghost town. The rise of Apalachicola added to the migration of people and the town's demise. The buildings, wharves and docks began to deteriorate before a small but intense hurricane visited on September 7, 1844, and destroyed what little remained.

Many people who died of yellow fever were buried in St. Joseph's Cemetery. So many deaths occurred at once that most were interred in open graves. The population went from six thousand to four hundred almost overnight. Local ghost hunting experts have mentioned seeing a portal (a doorway to another world) in the Old Port St. Joe Cemetery. This concept is possibly similar to a parallel world, as in the C.S. Lewis Narnia stories, or a time portal, perhaps allowing a gateway to the past or future.

Legend suggests that God sent the storm for a Sodom and Gomorrah–type cleansing, as the city had become wicked. Find out more about the city, the occupation by French, Spanish and British and its Civil War stories by

St. Joseph's Cemetery.

visiting the Constitution Convention Museum Historic State Park near Port St. Joe off Highway 98.

On July 25, 2014, the lighthouse and keeper's quarters were moved to St. Joseph Bay from Cape San Blas and erected on a new platform. This was a more secure location, as storms had caused previous lighthouses to fall into the sea. The lighthouse has had its fair share of deaths. In 1932, lighthouse keeper Ray Linton shot himself. Perhaps the hard work of climbing all the stairs twice daily coupled with the loneliness and responsibility became too much for him. In the 1950s, two men were painting the tower when their safety rope failed and they both plunged, screaming, to their deaths. According to Marlene Womack in her book on ghost towns, some visitors have heard knocking and tapping on outside walls, along with screaming and moaning at dusk.

However, in spite of the unsolved murder of a lighthouse keeper, thirty-eight-year-old Marler, in 1938, as well as various wrecks in nearby waters over the years, no definitive sightings of ghosts have been reported, and the ladies who work in the gift shop have not experienced any evidence of hauntings.

With the death and destruction in St. Joe's past, it would be odd if there were no ghost stories attached to the area. Older residents tell of a ghostly

Port St. Joe Lighthouse.

gentleman who would approach travelers and ask them if they would be so kind as to tell Miss Molly that he would see her on Thursday. Aunt Molly once lived in Apalachicola but has been dead for years, according to Womack in the *News Herald* in November 1987.

This whole area, complete with pirates, bootlegging and natural disasters, is an ideal location for ghost hunting. Money Bayou at nearby Mexico Beach has a story of pirate loot buried in the sand. Digging has taken place, but the more one digs, the deeper the treasure sinks into the shifting sand.

In Alan Brown's book *Haunted Big Bend*, you can read of two more stories for this area. The first relates to the Gulf County Courthouse at Wewahitchka, where the shooting of a sheriff took place. The victim's spirit lives on and is felt in cold spots, flashes of light and footsteps. Brown also tells of the eerie ghost hearse that appears at Sumatra or East Point near the railway track.

SOUTHPORT

Situated on North Bay and Dear Point Lake, to the north of Panama City, lies the small community known as Southport.

Untimely death was a frequent occurrence in days gone by, especially in the Panhandle with so much water everywhere. Children were not routinely taught to swim as most are now. There would have been neither the time nor the money for such an important life skill.

Dead bodies were buried quickly in this hot and humid place, as the smell of a dying body would be putrid and unhealthy for the living. Various embalming techniques were used; one such was to preserve the body in alcohol. Embalming fluid was injected into dead bodies' arterial systems, slowing decomposition. Other fluids may be drained from the deceased and replaced with preservative, enabling the body to last longer than a few days until burial.

A Southport family who lost their beloved seventeen-year-old daughter in a drowning accident was too distraught to bury her underground and decided on alcohol embalming followed by placing her body in a glass tube so they could continue to look at her. Locals said they could hear crying at night emanating from the bedroom she was lying in. When another member of the family died, she was buried with them in Southport Cemetery.

This was not unique; a family in Callaway kept their daughter at home in the same way until her lovely blue eyes faded and sank into their sockets. It was an expensive process, costing $160, a large amount for the late 1800s.

I believe the photograph to be of Ella's grave in Southport. She is buried next to her infant brother, Joseph, only one day old. "Budded on earth to bloom in Heaven" is inscribed on his small stone. Her much larger edifice has a flowery Victorian poem:

She sleeps beneath her native earth
And near the spot that gave her birth.
Her youthful feet trod flowers that bloom,
In beauty over her earthly tomb,
She rests beneath her native earth,
With grateful hearts we'll sing her worth:
Her gentle ways shall ever dwell
In hearts that knew and loved her well.
And oft we'll lift the tearful eye
To hear her calling from the sky.
Oh how could we her absence bear,
But that we hope to meet her there.

There are no dates on Ella's monument, but my research suggests that she died in 1892. She was the daughter of Stephen Anderson and his wife, Martha Ann "Annie."

Perhaps she was a relative of Captain Charles Anderson, a well-known and respected local fisherman. The very popular restaurant Captain Anderson's on North Lagoon is no doubt named after him, as are Captain Anderson's Marina and the boat of the same name that takes locals and tourists into the Gulf to fish. He is connected to a ghostly tale concerning the wreck of the schooner *Mary C.* This ship sank in stormy seas off Twelve Mill Hill, now known as Long Beach, in the Gulf of Mexico in 1906. The winds were hurricane force, and it is not surprising that three boats, including *Ella A.* (named for his daughter and dead sister), passed near this overturned vessel but were unable to help due to the stormy conditions.

Louis Davis on the *Louie* saw five sailors atop the capsized boat on his return from Pensacola. They waved frantically for help, indicating that they could not swim, but Louis knew his boat would be unable to rescue them. Jesse Ward was next to see them as he passed in the *Lucy H.*, but he could not get near enough to help. Captain Anderson aboard *Ella A.* saw them too. By the time the three captains returned to St. Andrews and reported the sighting, the storm had abated, so the tugboat *Larry Joe* with Sim Stephens at the helm set off to rescue the men. Sadly, he only found the boat; there were no survivors.

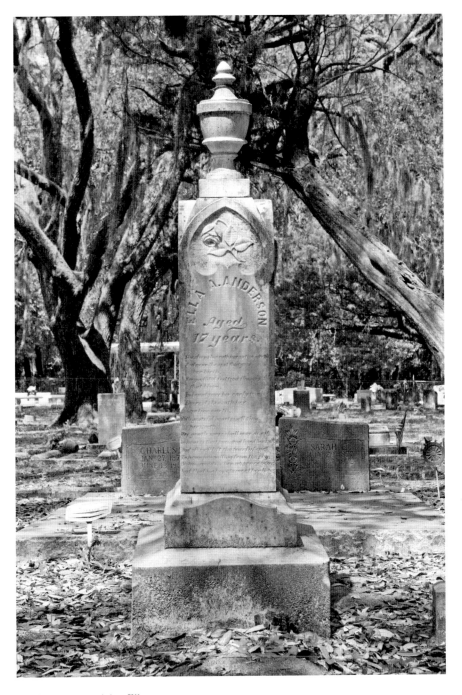

Southport memorial to Ella.

He towed the boat ashore, where the contents were investigated. Locals climbed on board the fated vessel out of curiosity but soon climbed off again, as they felt an uncomfortable eeriness. This was not too surprising, as they discovered the dead men's clothes, food and other belongings—most notably a black suitcase, a symbol of bad luck at sea. Black is a symbol of death and the depths of the sea.

MARIANNA

Sometimes called "Florida's Alamo," the Civil War Battle of Marianna took place on September 27, 1864. Following a skirmish to the northwest, seven hundred Union cavalry and mounted infantry moved south under the command of Brigadier General Alexander Asboth. Hungarian-born Asboth always wanted to be a soldier, but his father pushed him to be an engineer. In 1836, he enlisted in the Hungarian army as an engineer and combined the two careers. He arrived in the United States in 1851 and was soon to join the Union army.

Meanwhile, Colonel A.B. Montgomery had a plan. He mobilized the Confederate soldiers to barricade the streets of the town and positioned his cavalry at Ely Corner, planning to ambush the intruders along West Lafayette Street. Even though the Confederates were outnumbered two to one, the Union soldiers were driven back. A second charge forced the Confederates to retreat to the town center with the Union troops in swift pursuit.

On reaching what they believed to be an unmanned barricade, they were ambushed by home guards hidden along the sides of the road that fired, causing the Second Maine Cavalry its heaviest losses of the war. General Asboth was shot and badly injured; his left cheekbone was broken and his left arm was fractured in two places, but he survived to tell the tale and was eventually buried in Arlington National Cemetery. The Confederates continued to the Chipola River and made a stand by the bridge, whose floor they pulled up.

St. Luke's Church, Marianna.

Meanwhile, the home guard was trapped in the yard of St. Luke's Episcopal Church, fighting on until they ran low on ammunition, at which point they moved into the church. The Union soldiers decided to burn the church down. One God-fearing soldier begged to be allowed into the church to rescue the Holy Bible before the torches were lit. He managed to perform this feat, and the Bible resides in a glass case in the rebuilt church today. Five of the soldiers were not so fortunate; they were burned almost beyond recognition. This is grounds for haunting, I think.

Not surprisingly with a battle of such magnitude, there are tales of hauntings in the area. The Haunted Places website mentions that a Confederate soldier killed in the battle still haunts the church basement. Various people have seen him and describe him as elderly, bearded and wearing clothing of the period.

The churchyard is an interesting one, with many Confederate soldiers buried here, along with a state governor, a senator and rumors of a ghostly lady in white. Perhaps they relate to the statue of Hattie E. Smith. Strangely, the census for 1900, when Hattie was only thirteen, has her listed as divorced. I imagine, as she has half brothers in her tree, that it was her parents who were divorced. She died at age seventeen in 1904. The most likely cause would be pneumonia or tuberculosis, big killers in the days before antibiotics. No wonder her father, Jefferson Davis Smith, a wealthy merchant, wanted a striking memorial for her.

Above: Historical sign.

Left: Monument of girl.

ELY CRIGLEY HOUSE

This house is believed to be the home of many restless spirits from the Civil War battle fought on the ground. The house was bombarded by bullets and even a cannonball. The dead would comprise men too old, too young or too unwell to be in regular military service. In battle accounts, it is referred to as Ely Corner. Originally, it was a manor house belonging to Francis R. Ely, owner of a 1,629-acre cotton plantation at 242 West Lafayette Street.

Listed in the National Register of Historic Places, this is one of the earliest antebellum houses in Jackson County. Built in 1840 by Francis Ely with natural limestone bricks made on the property by slaves, it was originally much larger. However, both wings have been removed; the west wing is called the 1840s House and faces Russ Street. Both buildings are included in the twenty-seven on the Marianna self-guided walking tour. With so many beautiful, historic buildings, it is well worth a visit.

The most interesting story is of a lady in blue, believed by many to be the ghost of a servant who worked here. Her apparition has been seen by numerous people who have lived in or visited the house. She wears an old-fashioned high-necked white blouse and a long blue skirt. According to

Ely Crigley House.

Dale Cox on twoegg.blogspot.com, she may have been a Creole woman brought from New Orleans by Francis R. Ely as housekeeper and reported to be stylish, sophisticated and very beautiful. She most often appears on the second floor at the top of the stairs.

THE RUSS HOUSE

The most notably haunted property is the Russ House; built by Joseph W. Russ in 1895, it now houses the Jackson County Chamber of Commerce. Strange noises and sounds have been heard by many. They are believed to be caused by the ghost of the original owner, Joseph W. Russ Jr., who lingers here. Russ lost all his wealth in the stock market crash and committed suicide in the house in 1930. Others believe the noises are those of children playing. Yet again, this is a Civil War battleground, and spirits may be connected to this horrific way to die.

More information can be found about this house in *Haunted Big Bend* by Alan Brown or by looking at the Emerald Coast Paranormal Concepts

The Russ House.

website. Also in Brown's *Haunted Big Bend* is the story of the Bride of Bellamy Bridge, a chilling tale of a young girl whose bridal gown caught fire between Marianna and Chipley. The lacy dress shot up in flames after contact with a candle, causing this tragic story and, not surprisingly, a ghostly one.

CHIPLEY

Just off Historic Highway 90 lies the small town of Chipley, once a thriving community due to the introduction of the railroad and the plantations full of cotton. The first business was a wine shop, established in 1881 by B.W. Berry—ironic really, as Washington County has been dry since 1899. Now, Chipley is best known for its watermelon festival in August and its ghosts. Founded in 1882 as Orange Hill, the town was renamed after railroad builder Colonel William Dudley Chipley.

It is strange to picture the early days pre-1892 when the town had no pavement and chickens, pigs, hogs and cattle roamed in the sand between the buildings, as well as in and out of the outdoor toilets. It was especially difficult for the ladies to walk around with their voluminous dresses; they held their skirts high and risked exposing their ankles. At least at night they would not be seen, as there were no streetlights, bar a few kerosene lamps. If an event was on during the evening, the young men would clear the walkways of livestock and their mess so shoes and dresses need not be ruined.

HARRY'S BAY OR THE RUNAWAY SLAVE

Harry was a runaway slave. Part American Indian and part black, he fled his life working on a plantation and hid in the swamps by Orange Hill, a dark and gloomy area full of tangled undergrowth and venomous

snakes. He was a frightening figure with his animal skins and matted hair. People still report sightings of him to this day, although he must be long since dead.

INDIAN OAKS

In days gone by when Indians roamed the swamps and hills around Orange Hill, a young Native American woman named Indian Oaks lost her husband in a raid. A kind settler, Mrs. Jones, offered some Native Americans eggs; unfortunately, she was heavy handed with the pepper, and the Indians accused her of trying to poison them. They returned to her dwelling and killed her and two of her children. More fighting ensued, referred to as Perkins Massacre. During this scuffle, Indian Oaks's husband was fatally wounded and his body tossed into a lime sink. Wracked by grief, Indian Oaks hanged herself by her hair in an old oak tree near the sinkhole that still stands to the north of Chipley to this day. It is claimed that on certain nights, you can hear her wailing in the wind.

MISS MOLLY

Miss Molly Thurman was walking past the old city hall in Chipley one sunny day when she was spotted by Tommy Schumaker. The year was 1929; he was laying bricks for the tower and was high up on scaffolding at the time. He was captivated by Molly and was lucky not to fall. She obviously made quite an impression, as they began to date and married in June the following year. Miss Molly became the librarian in this building, now the Washington County Chamber of Commerce.

The old city hall is part of Chipley's haunted tour in the fall. Located on the corner at 108 North Fifth Street, this brick building dating from 1929 has had few renovations, thereby retaining its architectural integrity. As was the fashion in buildings in the Southwest at the time, it has features of Mediterranean Revival, especially Spanish. Bertram Grosvenor Goodhue is responsible for this trend, as he made a study of Latin American architecture in 1915 and held an exposition in San Diego. It gained much publicity, and other architects began to look at the rich variety in South America and

Old City Hall in Chipley.

Spain. The brick used is from Hall's Brickyard west of Chipley High School on Brickyard Road.

Orbs have been seen here, and local historian Dorothy has herself experienced strange happenings. Dorothy was leaving the building one evening when she noticed that lights were still on. She went and turned them off. When she mentioned this to some of the work crew, they looked at her in disbelief and said that the power to the whole building had been turned off hours earlier.

There have been other instances where lights and computers have been turned off at night, only to be found up and on in the morning before any of the staff have arrived. It is thought that Miss Molly is checking on everything in her one-time workplace.

THE GINGERBREAD HOUSE

This quaint blue house on the corner of Fifth and Church Streets was built in 1898 by the Jones family and then purchased by Albert Myers in 1921. It has changed hands a few times since and is run as a catering business now. The

The Gingerbread House.

Gingerbread House is one of the oldest buildings in Chipley and also one of the few to survive the two fires that have ravaged the town. May 14, 1898, saw the "year of the big fire" destroy thirty-five buildings in the twenty-year-old business district. A little over two years later, another fire swept through the town. Rumors of ghosts persist in the Gingerbread House. A lady in gray has been seen by a few people on different occasions wandering the hallway and turning into the blue room. This may be the spirit of Mrs. Jones, who died in the house. There are also tales of people hearing a small girl playing when the house has been empty.

CINDY'S CONSIGNMENT

When visiting Chipley, drop in to this friendly store for a bargain or two. Previously, the building housed a doctors' office upstairs and, as was often the case and sensible too, a pharmacy downstairs. It survived the 1901 fire, as it was mainly constructed of brick. "The awning in front of Dr. Farrior's brick stores was damaged but the stores remain intact," quoted the Chipley paper after the fire.

However, a different kind of tragedy struck the pharmacy one day in 1915 when a young lad who worked in the drugstore was electrocuted getting a drink from the soda machine and died. Not surprisingly, this four-story building dating from 1901 is thought to be haunted. Blue and white orbs have been photographed inside and, more sinister perhaps, a red one in the alleyway outside; apparently, blue and white are harmonious, while red is full of negativity. Noises such as footsteps have been heard, as have dragging and scraping sounds. Bats in the attic may have accounted for some of the noises in the past, but they are no longer in the rafters, and the steps sound more like children playing.

MR. SELLARS

Mr. Earl Sellars operated the *Washington County News* out of the large building on Northwest Railroad Avenue from 1927 until 1940. He then bought the smaller building next door, where the paper is housed today. The large building, dating from 1900, houses Habitat for Humanity now, although it has also boasted a jeweler, an antique store, a drugstore and a dry cleaner, among other things. Many have seen the ghost of Mr. Sellars, long since passed, entering the back door of the new building and walking through to the newspaper office. Staff has also noticed drawers opened and chairs turned around when they have been out.

The ghost story Chipley is most famed for is the Lime Sink, a tragic tale involving the drowning of two teenage girls and subsequent haunting. This story can be found in Alan Brown's *Haunted Big Bend*. Also of note and deserving of its own chapter is the tragic tale of the Dykes family.

JOHN DYKES

In the early 1900s, a man named John Dykes served as the local postmaster. Dykes was well respected and not known for aggressive behavior. However, when the manager of a local turpentine works, S.A. Walker, turned up dead, Dykes found himself accused of the murder. They had argued some days before, as Dykes, a human rights activist, was displeased with how Walker withheld mail from his workers, a practice that was both unkind and illegal. A coroner's jury charged Dykes with Walker's death, but before he was able to go to trial, a masked mob dragged Dykes from the jail and shot and lynched him on April 15, 1916. The lynch men were never formally identified or punished for the crime; Dykes's siblings believed that people in this small community knew or guessed the perpetrators, some of them perhaps prominent figures, but chose to protect their identities. Rumors swirled that Dykes was in fact innocent and the true murderer instigated the lynch mob to divert suspicion from himself. Perhaps the jailer, Carlton Jackson, could have kept a tighter hold on the keys to Dykes's cell, too. The siblings tried hard to find out more but were hindered at every step. They believed that the detective they hired was bought off and had to give up their pursuit of justice. John Dykes is buried in Dykes's Cemetery just after the 289 crosses Highway 77 between Chipley and Panama City.

Such injustice may be the reason for strange occurrences on the road outside the cemetery. Perhaps John Dykes is unable to rest in peace. One night, an ambulance was flying along this road when those inside saw a

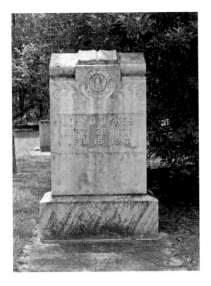

John Dykes's gravestone.

man in front of them. The driver was unable to stop in time and, horrified, drove straight through the figure. The emergency response team immediately went back to help the poor man, but he was nowhere to be seen.

Sometime later, a lady with no prior knowledge of this story was driving from Southport to Chipley one rainy evening when she saw a man at the side of the road just outside Dykes's Cemetery. She had to veer to avoid hitting him. Slowing down, she looked in her rearview mirror and saw the man stand up straight before disappearing from sight, or he would most certainly have been hit by the next approaching car.

Dykes's story continued into the 1930s, with the next generation and his son John Dykes, who bore his father's name. The tragic death of his father, the stigma of having an accused murderer for a father and the years of the Depression were taking their toll on John Dykes, the younger. He was noted by an acquaintance called Hawk to say that he wished for him and his family to "be taken out of this world at one time, all together," according to a quote from E.W. Carsell.

Be careful what you wish for. On Saturday, January 18, 1936, a fierce tornado ripped through Chipley, killing seven people and injuring twenty-five. The Ebenezer Baptist Church was twisted from its foundation, and nearby, the house of John Dykes was destroyed.

The family—John, his wife, his son John, his daughter Evelyn, his younger son Willie and his sixteen-month-old baby Kelly—and two visitors were chatting around a cheerful fire when the tornado hit. The two visitors dashed out of the house and leaped into nearby bushes; they were injured but lived to tell the tale. The Dykes family was not so fortunate. The dog survived and the next morning helped the villagers find the bodies, as they were scattered some quarter of a mile or more away from where they had been the night before. All had their clothes ripped off by the force of the winds, and the baby had been blown against a tree.

Three generations of the Dykes family were dead within a few short years and under horrific circumstances. The victims of the storm are buried in Glenwood Cemetery in Chipley.

Glenwood Cemetery has a haunted tale of its own. Vivian McDonald, wife of the late mayor Tommy McDonald, was tending to his grave not long after his death when she saw a veteran in a wheelchair coming over the hill. He had a missing leg and looked somewhat ragged, wearing a banner around his head in the style favored by Vietnam vets. Vivian had just put a military marker on the foot of her husband's grave and was busy pulling weeds. The man wheeled his chair to the nearby pathway to speak: "How are you?"

"Fine, how are you?" replied Vivian, bending to remove another weed.

When she looked up, he had disappeared. She drove around the cemetery in her car, but he was nowhere to be seen.

Vivian is no stranger to ghostly encounters, as she believes her son's house in Chipley is haunted. He lives with his family on Main Street in a house of one hundred years or more. The house used to belong to Kate Smith, principal of the local elementary school. One evening, on the day before school was to start after summer vacation, Vivian's son and daughter-in-law tucked their young daughter into her bed upstairs early because of school in the morning. They were sitting downstairs when they heard much bumping around above them. Venturing upstairs, they found their daughter out of bed. Insisting that she return to bed and go to sleep, they were surprised when she said, "Yes, if you tell that lady to get off my bed."

They did not think too much about this strange comment until some months later, when the little girl changed to another school. Taking her into the foyer, she looked at a picture of the principal on the wall and announced that this was the lady who had sat on her bed. It was, of course, Principal Kate Smith.

DEAD RINGERS

Back in England in the 1500s, the land was thickly forested, and medieval men began to run out of room to bury the dead. Bones were dug up and removed to a "bone house" and the land reused for the newly deceased. In so doing, they discovered one in twenty-five coffins with scratch marks on the inside of the lid. How terrible to wake up in the darkness with no one to hear your screams and no way out. One horrible story is of an early philosopher, John Duns Scotus, who had his tomb reopened and was found outside his coffin with torn and bloody hands, having fought to escape from untimely interment in 1308. This influential thinker was prone to having fits that rendered him deathlike. He had a servant to watch out for these occurrences, but unfortunately, he was not on hand when the last one happened. On returning, he declared his master to have been buried alive. The tomb was opened, and the servant was proved correct.

This is one reason a "wake" was held by the family after a person was presumed dead. The body would be laid out on a large board, perhaps a door placed on trestles or the kitchen table. The relatives would sit all night by the corpse in case it should wake. I'm not sure how often this happened, but I expect there were instances of people being thought to be dead who were in fact in deep comas or suffering from catalepsy with rigid body and limbs. Some cultures still have a wake today as a chance for friends and family to pay their respects, view the body and say goodbye. The funeral usually takes place the next day.

Due to this worry of being buried alive, night watchmen were introduced. Watchmen were a deterrent to grave robbers, which was a common practice in Victorian England. Such criminals were sometimes thieves after rings and other sellable commodities but also medical professionals looking for cadavers necessary for medical science. Medical students were very short of bodies for anatomy lessons, and a dead body could command a reasonable price at the back door of a hospital; much valuable information was learned this way.

The night watchman had another purpose. The finger of a recently dead body would be tied to a string before the coffin lid was nailed shut and lowered into the earth. If the recently deceased should happen to wake and move, the string would be tugged, and a bell attached to the other end would ring and alert the watchman. If someone looks remarkably like another person, living or dead, we may say they are a dead ringer for this lookalike.

However, the phrase "dead ringer" probably originates from horse racing. After bets were placed, a faster horse was sometimes exchanged for a slower one that looked remarkably similar. This form of cheating was called using a ringer. The word *dead* in this instance means "precise," as in *dead center*. Fascinating how language and sayings evolve.

A strange tale from Glenwood Cemetery in Chipley is that of Mary J. Nepper. In the year 1876, she collapsed and was pronounced dead. Friends and family buried her in an aboveground tomb. One night soon after the funeral, thieves tried to rob her coffin, hoping for jewelry. What a shock they got when she sat up and looked at them! She continued to live a fruitful life for over thirty years, giving birth to three children, before dying on June 5, 1911, and returning to her previously visited resting site.

Glenwood Cemetery is home to another local ghost tale. The wife of a local mayor believes she saw her recently deceased husband in the area. He died in middle age, probably as a result of inhaling Agent Orange, the herbicidal warfare chemical sprayed in Vietnam. His wife, not prone to delusions, was certain she saw him when visiting his grave. One moment he was standing there, wheelchair-free at last, and the next he had disappeared from sight faster than humanly possible.

BONIFAY

B onifay is a small town in Holmes County, Florida, named after a prominent family in Pensacola who own a brick factory.

On West Kansas Avenue stands an imposing mansion. Surrounded by white iron fencing with Mediterranean Revival–style architecture is Wait's Mansion, so called after the builder, George Orkney Wait, who had the home built for his own use in 1920. More on the design can be found in *The Heritage of Holmes County* (2002). A brief history of his family can be read in *A Guide*

Wait's Mansion in Bonifay.

to Florida's Historic Architecture. I uncovered nothing to suggest that members of the family would have lingered in the house after death. However, the house has changed hands many times, and something untoward may not have been reported.

The Haunted Places website attests to the house giving off odd vibes. Although it is empty, shadows are seen in upstairs windows some evenings, as well as lights appearing on the ground floor.

Visitors from the mansion's days as a bed-and-breakfast have claimed to hear strange noises, such as china breaking, as well as see odd lights and feel cold spots.

FOUNTAIN

ountain, the largest community between Tallahassee and Pensacola in Northwest Florida, lies on U.S. Route 98. Associating the community with the word *large* at all feels like an exaggeration, as Fountain boasts a Piggly-Wiggly and a Dollar General and not much else. Most roads appear to be dirt and are hard to navigate. The name is connected to nearby town Ponce de Leon, named after the sixteenth-century Spanish explorer who visited Florida in search of new lands, treasures and the mythical fountain of youth.

An exorcist was called to this town by a lady's increasing alarm at strange happenings in her house, along with her husband's reaction to them. She lived in a large blue house in Counts Avenue, since pulled down. The area is one with a very violent past, including bloody Civil War battles in the 1860s. Then, in the following years when this house was a church, it may have housed a pastor who abused young boys in his care.

The lady of the house would find inexplicable scratch marks on her children's arms. They would regularly feel their hair pulled. Sometimes while eating in the dining room, their hands would be slapped and the food from their plates would fly toward the ceiling. Ghostly faces would appear behind people in looking glasses. Most worrying was her husband; he had possibly begun to identify with this entity and stopped washing and grooming himself.

An overwhelming sense of sadness enveloped the house. The final straw for the owner was when she saw a casket in her living room, originally the church sanctuary, so a medium was called in to exorcise the ghost.

Julie Gordon and an apparition in a mirror at Fountain. *Courtesy Julie Gordon.*

Fountain does seem to conjure up the bizarre. On the Ghosts of America website, a contributor talks of staying in a relative's cottage where each night at 3:33 a.m. he would be aware of bouncing at the end of the bed. Turning on the light would cause the movement to stop. He could find nothing in or under the house to explain this, but if he slept on the floor, all was peaceful but not very comfortable. I have not been able to verify this account, but the website holds further information.

According to Kaplan in the *News Herald*, "In 99% of cases, people call a ghost investigator because they are frightened by the phenomena more so than actually threatened." Demonic spirits are extremely rare; most ghosts are friendly, and Kaplan suggests having a ghost in the house can be a positive experience. Kaplan's research suggests ghosts are attracted to water, making Florida a likely destination for both ghosts and tourists.

DEFUNIAK SPRINGS

Nestled around Lake DeFuniak is the delightful small Walton County town known as DeFuniak Springs. Home to many beautiful old houses and a railway station dating back to the 1880s, it is well worth a visit. The library, built in 1886, is the oldest in the state of Florida that is still serving the local population.

There are at least three ghost stories to be found here, and I expect there are more to be discovered.

An unlikely sounding venue for a haunting, H&M Hot Dog at 43 North Ninth Street has been selling hot dogs at this location for over fifty years. It is the second-oldest hot dog stand in the country, and some say the hot dogs from here are the best in the world. Staff told me they hear whistling or feel someone blowing on the backs of their necks, even though they are alone in the building. The back door has been known to open and shut all by itself. The previous owner witnessed his spatula spinning around and around on its own.

The Little Big Store at 35 South Eighth Street is reputedly haunted. Worth a visit for nostalgia alone, this wonderful store has all sorts of curios, and buying candy from jars by the quarter takes me straight back to yesteryear. Items have mysteriously fallen off shelves, and footsteps have been heard in the aisles, possibly those of a previous owner who can't bring himself to leave. Perhaps he likes to check that the store continues to retain its old-world charm.

DeFuniak Springs Library.

Hotel DeFuniak is another haunted building. A few doors down from the Little Big Store on the corner of U.S. 90 sits the 1920s bed-and-breakfast with its haunted tales. Upstairs in room 008, or the Aviary Room, both staff and guests have reported seeing two children appear and run around the hallways. No children have been booked in at the time. Sometimes a lamp moves across room 008 on its own.

Built in the 1920s, it began as a Masonic lodge. The emblem can be seen at the top of the building. Lodge 170 met upstairs, while downstairs was leased for retail. The Great Depression caused the Masons to sell the building to an attorney. Upstairs became boarding rooms, and downstairs was used for dining. During the 1940s, it became the Lightfoot Drug Store, and the owner, Marshall James Lightfoot, lived there too and ran a small motel and a "greasy spoon" restaurant.

After Lightfoot's death in 1965, the building became a furniture store. Then in 1998, six families bought it between them, restored it and returned it to a hotel and restaurant. As written by Jennifer McKeon and Tom McLaughlin in a January 2016 edition of the *News Herald*, "Tom and Pam Hutchins purchased the hotel in early 2011 and decorated each of the twelve rooms with European antiques. They opened the adjoining restaurant in 2003."

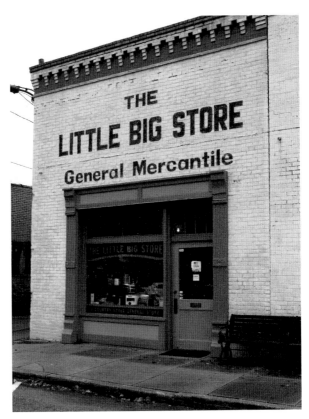

Right: The Little Big Store.

Below: H&M Hot Dog.

The hotel is awaiting an uncertain future and sits empty…as far as we know, except, perhaps, for the ghosts of the two young children.

Sunbright Manor is a grand Victorian two-story house with an octagonal tower and double porches, located at 254 Live Oak Avenue West. Built in 1886 and completed in 1890, it has been listed in the National Register of Historic Places since 1979. Unrelated visitors who have stayed here reported doors opening and closing on their own on windless days, as well as other odd, undefined occurrences. Neighbors across the street think the house has a weird vibe, and while sitting on their porch of an evening, they have seen shadows and movement behind upstairs windows although they know the house is empty. The house certainly has a strange look to it and has changed hands many times.

No one seems to wish to stay there for long; the original owner, J.T. Sherman of Brodhead, Wisconsin, used it with his family during the winter months. Another owner was Florida's twenty-second governor, Sidney Johnston Catts. He resided here from 1924 until his death in 1936. His wife, Alice, stayed until she died in 1949. Alice is best remembered for her terrible driving. Perhaps the house is haunted by people she terrified on the roads!

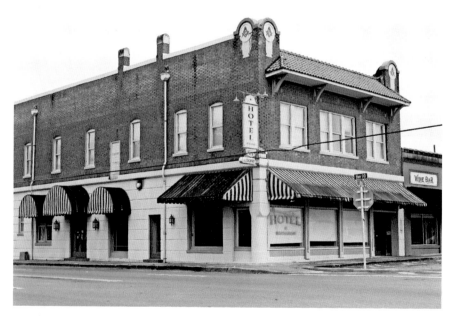

Hotel DeFuniak.

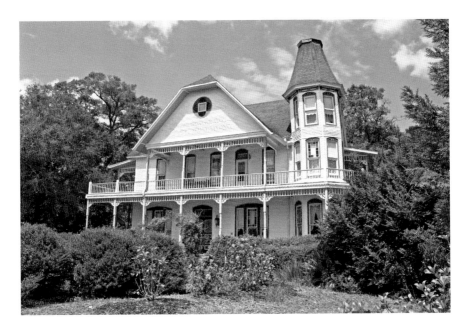

Sunbright Manor.

Perhaps Mr. Catts died in the house, as he reportedly died in DeFuniak Springs somewhere. He may not have been a popular man; he and only one other man in the area were pro-prohibition, and he was publicly heard to refer to black people as "an inferior race" when he refused to criticize two lynchings in 1919. That's grounds to haunt him, I would say.

Also in DeFuniak Springs is the alleged haunting of the Emergency Operations Center (EOC). A young girl who died tragically on land on which the EOC was built has been haunting this location, especially at midnight. Strange noises have been heard in the hallways and bathroom. Some dispatchers have been locked in a stall, unable to get out even with the door unbolted. Sometimes toilets flush on their own, and the sound of running taps can be heard, although they cease to flow when the room is entered. A newly hired worker saw something moving by the bathroom door. She screamed and left the building immediately, having decided to quit her job.

Many workers have heard inexplicable sounds. Despite extensive research confirming a ghastly murder on this site, they have found no documentation of the girl's name. They have nicknamed the ghost Sally Mae. (Those of you familiar with Harry Potter may be reminded of Moaning Myrtle, who haunted a bathroom at Hogwarts.) "Sally Mae" was outside in her yard

147

in the early 1940s when she was spotted by a group of black males who were walking along the nearby railroad track. They beat her, raped her, chained her to a large oak tree and set it on fire. The house, tree and girl were all burned down, along with any evidence of the horrific crime. The perpetrators were never caught.

WESTVILLE

An hour north of Panama City, it feels like a different country, not just a different county. Holmes County has rolling hills and a wealth of verdant green trees. I saw cows grazing, fields of maize, hives of bees and much agricultural activity in fields along the way.

Westville is best known as a one-time home of Laura Ingalls Wilder; her husband, Almonzo "Manly" Wilder; and their daughter, Rose. Leaving Minnesota, where they had stayed with Manly's parents for about a year, the three of them headed south in the hope that Manly's health would improve with a warmer climate. They were to join Laura's cousin Peter Ingalls and his southern wife in Northwest Florida.

In 1891, their best way to travel was by train. They arrived in the fall, when the Florida sunshine was still quite fierce and the humidity high. Laura hated it. She disliked the look of the eerie Spanish moss as it dangled from the live oaks, and she did not get on well with the locals, who thought she was a stuck-up northern girl. In William Anderson's biography of Laura, he quotes her as describing Westville as a land "where the trees always murmur, where butterflies are enormous, where plants that eat insects grow in moist places and alligators inhabit the slowly moving waters of the rivers. But a Yankee woman was more of a curiosity than any of these."

Manly may have felt his health improve, but Laura's deteriorated. In less than a year, they headed home to South Dakota. A plaque remains to show where they were in Westville, and the church they attended, Mount

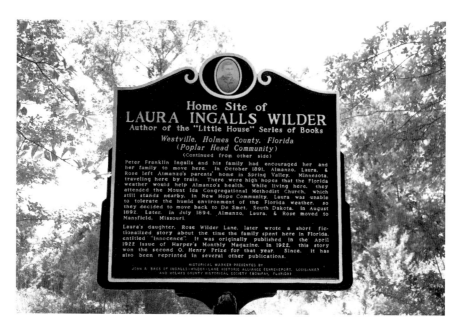

Laura Ingalls Wilder plaque.

Ida Congregational Methodist, is nearby; across the road is a cemetery with gravestones that bear the name of Ingalls.

However, the church I was intent on finding was Corinth Church. Well off the beaten track, surrounded by fields and only accessible by dirt roads that made the wheels of my car spin as well as confusing my GPS, it was hard to find. Nor was it very welcoming, with NO TRESPASSING signs and security cameras. The church is no longer in use and looks sad and dilapidated. The only signs of life in this land that time seems to have forgotten were the buzzing of bees and the chirping of crickets. Unfortunately, vandalism has been a problem in the past, due in part to the building's lonely location and perhaps because of its association with a murder and a haunting.

Legend tells of the gruesome murder of a young boy at this location, although I have been unable to confirm this. One day back in the 1960s, a boy was playing alone in the church. Or at least, he thought he was alone. Unbeknownst to him, a convict had escaped from a nearby prison and chosen the church as a hiding spot. While the boy played, the convict crept between the pews. Perhaps the boy caught sight of the convict, who panicked at the thought of being found out. Or perhaps the convict couldn't control his murderous impulses with such a defenseless and unsuspecting

victim at hand. For whatever reason, the convict sprung from his hiding place and viciously murdered the child. Since then, people have claimed to see apparitions of both the dead boy and his murderer in the vicinity of the church and churchyard.

Some visitors have claimed that bloody handprints can be seen on the inside walls of this wooden church to the left of the entrance. It is hard to see through the dust-encrusted windows. It is possible to make out the wooden pews, a lectern and an aged piano, probably long since out of tune, but nothing more without violating the trespassing signs. A more likely explanation for the marks is that they were made by oil from a worker's greasy hands during renovation.

BIBLIOGRAPHY

Books

Anderson, William. *Laura Ingalls Wilder: A Biography*. New York: HarperCollins, 2007.

Brown, Alan. *Haunted Big Bend Florida*. Charleston, SC: The History Press, 2013.

Caswell E.W. *Washington, Florida's Twelfth County*. Tallahassee, FL: Rose Publishing Co., 1991.

Cox, Dale. *The Ghost of Bellamy Bridge*. Bascom, FL: Old Kitchen Books, 2012.

Davidson, Michelle. *Florida's Haunted Hospitality*. Atglen, PA: Schiffer Publishing, 2013.

Dean, Susie Kelly. *On Saint Andrews Bay, 1911–1917*. Tampa, FL, 1969.

A Guide to Florida's Historic Architecture. Gainesville: University Press of Florida, 1989.

The Heritage of Holmes County. Jacksonville, FL, 2006.

Ling, Sally J. *Out of Mind, Out of Sight*. Charleston, SC: Create Space Independent Publishing, 2013.

Spiva, Ernest. *Growing Up on Grace*. N.p.: Lulu Publishing Services, 2015.

Titler, Dale M. *Unnatural Resources*. Upper Saddle River, NJ: Prentice Hall, 1973.

Womack, Marlene. *The Bay County of Northwest Florida*. Dothan, AL: New Hope Press, 1998.

———. *Ghost Towns, Mysteries & Tombstone Tales*. Panama City, FL: Love It LLC, 2015.

Leaflets

Apalachicola Historic Walking Tour. Apalachicola Bay Chamber of Commerce.
Battle of Marianna Walking Tour. Jackson County Tourist Development.
Cape San Blas Lighthouse. St. Joseph Historical Society, Inc.
Chapel, George L. *A Brief History of the Apalachicola Area.*
Constitution Convention Museum State Park. Florida State Parks.
Falling Water State Park. Florida State Parks, 2007.
Guide for a Walking Tour of Camp Helen State Park. Friends of Camp Helen State Park.
Historic Downtown Chipley Walking Tour. Washington County TDC.
Historic Walking Tour of Downtown Panama City. The Historical Society of Bay County.
Self-Guided Tour of the Marianna Area. Main Street Marianna & Chipola Historical Trust, Jackson County, Florida.

Personal Interviews

Belinda Betz, June 14, 2016. "Civil War Veteran" chapter.
Jeanette Brightwell, May 22, 2016. "The Smoker of Callaway" chapter.
David and Dennis Byrd, September 6, 2016. "The Old Lynn Haven Grammar School" chapter.
Monica Cramer, May 10, 2016. "The Cove" chapter.
Erin Drummond, November 2016. "Jingle Bells" chapter.
Audra and Brendan Ely, as well as Sean Austin, June 11, 2016. "Ripley's Believe It or Not!" chapter.
Cynthia Christian Farmer, June 10, 2016. "Chipley" chapter.
Julie Gordon, November 9, 2016. "Roger," "Fountain" and "The Old Bank at St. Andrews" chapters.
The Reverend David K. Green, June 2, 2016. "Marianna" chapter.
Gladys Grimsley, February 26, 2016. "Gladys Remembers" chapter.
David Hayes, May 11, 2016. "Caffiend's 247" chapter.
Michael Hunter and staff, November 20, 2015. "Doppelganger" chapter.
Deborah Matthews, December 2015. "DeFuniak Springs" chapter.
Vivian McDonald, June 10, 2016. "Chipley" chapter.
Barbara McMinis, February 23, 2016. "The Ritz" chapter.
Diana McQuagge, May 11, 2016. "Southport" chapter.

Charlene and David Messer and staff, February 11, 2016. "Aunt Minnie's Closet" chapter.

Gregory Mote, April 2, 2016. "Gladys Remembers" chapter.

Dorothy Odom, June 10, 2016. "Chipley" chapter.

David Parmer, November 12, 2015. "Millie" chapter.

Anne Robbins, November 2015. "Grandmothers Return" and "The Cove" chapters.

Delores Roux, March 3, 2016. "Apalachicola" chapter.

Kevin Shea, February 17, 2016. "Bayou Joe's" chapter.

Richard Stone, November 2015. "Grandmothers Return" chapter.

Jennifer Vigil and staff, November 2, 2016. "The Old Bank at St. Andrews" chapter.

Websites

airforce.togetherweserve.com

www.exploresouthernhistory

www.Exploringflorida

www.hauntedplaces

www.southernfloridahistory

www.strangeusa.com

www.wikipedia

ABOUT THE AUTHOR

 everly Nield has spent most of her life in England, where she studied history and education at the University of Cambridge. In 2006, Beverly, along with her family, moved across the pond to start a new life on the shores of the Gulf of Mexico. Keen to be involved in the area, Beverly initiated a haunted historical tour of downtown Panama City. The past has always held a fascination for her, along with all things mysterious.